Faces
USA

Arnold Newman

AMPHOTO
American Photographic Book Publishing Co., Inc.
Garden City, New York

Published in Garden City, New York, by American
Photographic Book Publishing Co., Inc. All rights re-
served. No part of this book may be reproduced in any
form whatsoever without the written permission of the
publisher.

Library of Congress Catalog Card Number: 77-73135

ISBN: 0-8174-2423-7 (Hardbound)
ISBN: 0-8174-2105-X (Softbound)

Manufactured in the United States of America.

Contents

Foreword 5

FACES—An Evolution 8

Color Portraits 10

Impressions 23

Notes on Techniques 25

The Great American Face Families 26

The National and Regional Families 99

Acknowledgements

It is indeed a precious phenomenon when a germ of an idea—arriving at a propitious moment in history—finds for itself an optimum environment for realization, and a team of people ready to nurture it with both tenderness and determination. The Great American Face program, sponsored by the Kinney Shoe Corporation and developed and executed by Ruder & Finn, Inc., clearly falls into this category. The still evolving phenomenon of FACES has already won a permanent place in the annals of photo-Americana.

As originally conceived, FACES was a wide-open invitation to all Americans to take part in capturing their own collective family likeness—in all its richness and diversity, in its infinite individualism and character—through the spontaneity of snapshots. The idea was to have Americans participate in their own definition, rather than remain bystanders in America's Bicentennial pageantry.

Because the concept inevitably embodied both mass appeal and philosophic substance, the unfolding timetable and scope of the program went far beyond the original commitment. We, as well as future generations, are indebted to the sponsors, Kinney Shoe Corporation, and especially Richard L. Anderson, president; Cameron I. Anderson, vice president; and John K. Aneser, director of advertising and marketing communications. We are also indebted, for their zeal and professionalism, to Ruder & Finn, Inc., and especially to Robert Bagar, senior vice president and creative director. Without the dedication and purposefulness of these individuals and organizations, FACES might have remained an intriguing but ultimately inconsequential exercise. Instead, it has become a remarkable photographic celebration and achievement of the American people.

It is to the further credit of the sponsor and its communications counsel—as attested by Arnold Newman—that their respective roles, while always significant, remained low-key and dignified throughout every stage of the project.

FACES is the result of the work of a great many individuals who gave unselfishly of themselves and their talents. Certainly all those whose images and photographs appear here deserve our praise and gratitude. Space will not permit us to record the contributions of each and every person who worked behind the scenes. Yet it would be remiss not to acknowledge the invaluable and diverse contributions of any of the following:

The judges: co-chairmen Charles Reynolds and John Durniak, photo-editors of, respectively, *Popular Photography* and *Time Magazine;* Dr. Robert U. Akeret, author of *Photoanalysis;* Irving Desfor, photography columnist for Associated Press; David Finn, fine arts photographer; Arnold Newman, portrait photographer; and Regina Reynolds, photographic consultant.

The exhibitors: the California Museum of Science and Industry, Los Angeles, Ca., host to the inaugural FACES exhibition; the Morris Museum of Arts and Sciences, Morristown, N.J.; the National Visitor Center, Washington, D.C.; the United Nations; the Georgia World Congress Center, Atlanta, Ga.; the many shopping centers throughout the nation which prominently displayed the Great American Face collection; and the Kennedy Center for the Performing Arts, Washington, D.C., which exhibited "Memorable American Faces," a prelude to the Great American Face exhibit.

Other organizations and people who made valuable contributions include: Senator Hubert H. Humphrey, whose commentary on FACES is part of the Congressional Record; John Warner, former director of the American Revolution Bicentennial Administration (ARBA), who designated FACES an official project of the U.S. Government; William Davis and James Keogh, who were instrumental in arranging a worldwide tour of FACES under the auspices of the United States Information Agency (USIA); Mayor Thomas Bradley of Los Angeles and Mayor Maynard Jackson of Atlanta for proclaiming Great American Face days in their respective cities; and Edie Fraser who championed the cause of FACES among many groups.

Others who contributed more than was expected of them include: Ken Lieberman, of Berkey K&L, technical consultant; Joanne Lupton, creative designer of FACES exhibitions; Carlos Schidlowski, of Great American Music Machine, who produced "Take a Look at the Great American Face," with music and lyrics by Tim Schumacher and Craig Donaldson; Alisa Zamir, of Fujita Design, graphics designer for all FACES materials; Dede Bagar, coordinator of shopping center exhibitions; and Joel Benson of Shopping Center Network.

Communications played a vital part in the success of FACES. Special mention should be made of the creative team of Ruder & Finn, Inc., particularly Adele Shainblum, who shepherded the project through all its phases, and Diane Michell for her able assistance; Norman Wasserman, who edited this book; Selma and Jerome Halprin, of Ruder & Finn, Los Angeles; Sam Keeper, of Ruder & Finn, Dallas; and also Joan Spector, Marjorie Liebman and John Turner, affiliates of the R&F Field Network.

To these individuals—and to the FACES shown in these pages, to America's talented amateur photographers, and to the millions of great American faces who are not included in this book—we are grateful for the warmth and depth of their responsiveness.

Foreword

by Thomas Thompson

We are warned by the sages and dissectors of our way of life that the American family is in explosion. The bomb has hit. Our pieces are splattered from communes to urban prisons where high-rises contain low spirits, where computers trace us, haunt us, confound us. John Doe, they say, is bored with his work; his wife, Jane, is alienated and frustrated; their children lie drugged on their pillows dreaming in Day-Glo colors. The elders of the tribe are confined to sun cities, where they can be ignored and forgotten, for age is an unforgivable crime. If we believe what we read, then across all of our faces must be the snail tracks of despair. The sand must be running out of the American hourglass. How soon will we join Atlantis, buried, unmourned?

I think not for quite a while, if indeed, ever. The doom-saying business is growing tiresome. It is always easier to scorn a play than praise it. Ask any critic. *Homo americanus* is still a smash hit on the stage of the world, and the run has no end in sight. For proof, consider what Arnold Newman has done—rather surprisingly, in fact—on the pages that follow. Arnold Newman is a photographer, one of the very best, and his reputation rests solidly on the shoulders of the mighty and the exalted. For over three decades, he has clicked his shutters at giants whose steps shake the earth. Locate, if you can, his 1974 book, *One Mind's Eye.* Enter thus into a museum where the celebrated are ensnared forever. See Francisco Franco, as arrogant and as panoplied as a Renaissance prince! Marvel at Igor Stravinsky, his bony frame an extension—almost a shadow—of his piano! Chill at Baron Von Krupp, the German steelmaker, his face a death mask, surely the most terrifying portrait ever taken!

Now you are ready to begin this book. No one here is famous; no one here has yet made footprints large enough to withstand the breakers of the centuries. But that was not Arnold Newman's assignment. He was asked to photograph 12 categories of Americans, symbolic representatives of all 200 million of us; class favorites, if you will, as a celebration of our Bicentennial year. The photographs are collected here in a volume that will mean something to Americans of a Tricentennial era.

Newman had no say in whom he was to photograph. Well, he was one of a panel of celebrated eyes who peered over thousands of entries in the Kinney Shoe Corporation's "Great American Face" contest. But not until he and his colleagues had winnowed the avalanche of snapshots down to the winning dozen did someone conceive the delicious— but maddening—notion: Why not dispatch Arnold Newman to the homes of these ordinary folks and do for them what he had done for kings, presidents, and maestros?

Newman accepted with considerable misgiving and in anguish from having given in to figurative arm twisting. "Who are these people?" he asked himself in stomach-gnawing apprehension. "What if they are boring? What if they are stiff? I won't have enough time. I should spend weeks, months around each of them in order to photograph them properly." But no one has enough time anymore, and suddenly Arnold Newman was off—his pockets stuffed with plane tickets, road maps, rental car reservations, and vague instructions on how to find Centereach, New York, Gaithersburg, Maryland, and Poway, California.

Six weeks later, he returned to his apartment on the West Side of Manhattan—a place where Martha Graham and Carl Sandburg and Marilyn Monroe had supped—fretting that he had not fulfilled his challenge. In the brief moments allowed for each subject, surely he had skimmed only the cream, if even that. Not until he transformed his hundreds of rolls of film into contact sheets, not until he had pored over these and marked the most promising with red grease pencils, not until he spread the ensuing enlargements about the floor of his studio until he resembled the lone survivor of a photographic eruption, not until then did Arnold Newman, a worrying man, permit himself a tentative smile . . . of contentment.

And well he should.

In truth, Newman brought back *more* than was bargained for. Oh, he produced the desired dozen portraits—twelve crisp, artfully composed, beautifully hued color photographs of each of the prize-winning subjects (Actually there are thirteen, since the winning baby turned out to be twins). But these were only the title pages in a unique series of mini-dramas; each containing in its way the revelation of shocks and

pleasures, the growing pains, the reachings out, the social pressures, the retrospective of American life two centuries after the nation was born.

A century or two hence, some Margaret Mead of then will do well to study these photographs. They are the modest but necessary record of a people and a way of life.

One word of explanation. It is important to understand that the twelve winners were chosen on the basis of the subjects' faces and the qualities of character, personality, strength, emotion, warmth, and humanity—as *reflected* in the snapshots entered in the Kinney contest. Not until Arnold Newman rang their doorbells and poked his cameras into the private corners of their lives did some surprises emerge. There is no need to comment on each category, for the purpose of photography is to look and wonder. But a few of these studies can tolerate some words as well.

The category of Teenage Boy is an appellation that conjures images from the American scrapbook— freckles, pimples, mongrel dogs, perspiring and desperate fumblings toward the girl in the next seat in the Bijou balcony, finely-tuned chariots, junk food, never enough money, goofs, gaffs, embarrassments. Paul Wagner, 17, of San Antonio, did not fit that mold. Arnold Newman encountered here another searcher, a child-man just at the edge of his family circle (Literally, in fact: Mark the group photograph.), not quite measuring up to his elders' desire that he throw a football farther than Joe Namath. Paul marches to his own beat. A caring high school teacher caught the rebel Paul, persuaded him that sports were not the be-all and end-all, turned him on instead to ideas, melodies, colors on a canvas. Now Paul Wagner is a fine artist, a budding scholar of modern art, and possessed of a direction for his life. Newman's eye caught the still-healing adolescent traumas in Paul's striking face. Can anyone examine these photographs and not recall what it was like to be 17 and different?

There is special poignancy in the category of Father. On one level, Milton Blackstone can be viewed as the stereotypic American breadwinner—driving hard, making his business successful, squeezing room for a romp with the kids, agonizing over market quotations, enjoying the attention of family friends and a well-furnished house. But look again. Catch the traces of worry in his eyes, of fear not altogether hidden. "I'm a man who never smiles," he said when he saw the winning snapshot of himself smiling broadly. Not even 50 on the day Newman was photographing him, Milton Blackstone faced the most excruciating of unknowns. The very next day he flew to Houston where Dr. Denton Cooley, the cardiovascular super surgeon, opened Milton Blackstone's chest, sawed through the

sternum, lifted up the heart, studied it, stopped it, and sewed in new arteries borrowed from the leg. The operation, how nice it is to report, was entirely successful. But if moments were precious to Milton Blackstone before, consider what they mean to him now, and tomorrow.

In Mansfield, Ohio, Arnold Newman found Ruthie Scott, who is black and beautiful and—like so many women of her age—at odds with herself. This face, which won the Young Adult Female category, is a repository of considerable success, but at a price. She was born in Watts, lived through the fires of the Sixties, found government money to pay for job training (Skeptics please note: It often works!), and became an air traffic controller at Mansfield's Lahm Airport—the first woman so hired. But her marriage broke, and when she tried to keep working, and at the same time make arrangements for the care of her five-year-old son Gerald, life became a pressure cooker. The job itself was grueling enough, juggling planes in a crowded sky. But tearing at her attention was the knowledge that her little boy wept when she left and wept again when she returned home. With regret and apprehension, Ruthie Scott resigned and moved back to square one—to Watts, there being able to deposit her son with her mother, while she began looking for another job. Arnold Newman suspects she will succeed, for the fire of ambition burns in her eyes, just as it does in millions of her sisters'. Wherever she goes, Ruthie Scott will be Ruthie Scott.

Steichen, I think it was, the Zeus of American photography, once said that the easier subjects to photograph are the very young or the very old, the reason being that these delegates from the beginning of life and the end of it care little about vanity. Whether Arnold Newman concurs, I do not know, but he brought wondrous tenderness to these portions of his assignment. Jason Jardine, almost six, is a Roman candle of a youngster, and the owner of a face that could be used in acting classes to teach emotions and expressions. "His is the most expressive face I've ever photographed," said Newman, in no small tribute. "And he is so full of beans that you alternately want to strangle him or embrace him." Young Jardine, son of a Washington, D.C., area fireman, led Newman a merry chase, tearing across fields of new-mown hay, visiting his father's fire station and warming Dad's hat and heart, conspiring and exchanging jokes with his best friend at the back of the school bus. Has there been a better photograph of the joy of being not quite six?

An experiment, if you will. Enjoy the photographs of the Schneider twins, new to the world, as shiny as unopened Christmas packages. Then, hurriedly, turn to the haunting photograph of an old woman, Keziah

Patterson. Three-quarters of a century will blur before your eyes. And then wonder, as I do, if these children will reach the milestone of 75 years with as much dignity, fulfillment, and contentment as Keziah Patterson. The name is Biblical and appropriate, for faith has shaped her life. Her church has soothed her pain of widowhood, of living alone on a farm. She has lived in the same house for half-a-century. When she first moved to the frame house, she could stand in the yard and see only two lights far in the distance—a reminder that somewhere out there was a turbulent world. Now lights surround her. The world has edged to her very door. But she remains bedrock, clinging like an endangered species to values fast blinking out. She tends her sheep, pounds out hymns on her pianos, raises vegetables, drives her car, rejoices in spring's first blossom, and fears not autumn or winter with the grayness and snow. "She is remarkable," said Arnold Newman. "She is a rare spirit, a woman of courage and peace."

You will encounter here the heroic visage of John Dorian, grandfather, exactly the same age as his century—76—when these photos were taken. There is power in John Dorian's life, sailing as he did on ships that searched all of the earth's seas, speaking as he did eight languages, knowing the beauty of hidden places and the electric shock of discovery. Now he is retired in San Diego, where he can still smell the salt and see the ships. He strains at his own anchor, walking to the shore and looking out with his tiring eyes, wondering why the years sped by so quickly, remembering. Now, he has the solace of a pot of petunias that bloom at his command, ten grandchildren not so small, three great-grandchildren, a dog, a bank teller who warms at his arrival, a canal whose fish tolerate his line. He cannot be shut up in an old folks home, for his life must be honored, not darkened in a back closet of the house. Study the great American face of John Dorian in the color photograph by Arnold Newman.

Are we in explosion? No, not according to the lives recorded on these pages. But wait—on the other hand—in many ways we are a fragmented society. Yet, one of the points this remarkable book makes is that we *are* a society with cohesive strains, and oddly, cohesive pressures. There is the glue of realism and dreams that can be realized. There is diversity and a respect for differences, and a kind of vibrancy that may belong uniquely to this nation alone. There is dramatic counterpoint in Teenager Amie Willis winning a Good Citizenship Award and the detachment of her Teenager counterpart, Paul Wagner. Look at the curious innocence of the Schneider baby girls—so fortunate in finding loving parents—and that of Baby Boy Matthew Marchese, whose birthright was guaranteed generations ago. And compare the intense aspirations of Mark Gridley as he designs automobiles at night, and Ruthie Scott's pilgrimage to Watts "to get it all together."

Some may find Beverly Burns just too appealing to be credible as a regional winner in the Mother category. Her face could easily grace the cover of a woman's magazine, but Arnold Newman is not a woman's magazine photographer, nor is Beverly Burns a model. Captured in an unposed setting, she comes across unmistakably as mother, wife, and businesswoman; both vulnerable and invincible. One also senses her determination to overcome a personal obstacle which she acknowledges but does not easily share.

You can begin anywhere in this book and come up with challenge and inspiration. Maybe this is what Arnold Newman means when he says that the accomplishments of these people are in simply living their lives—which are often not so simple. Sometimes, the families are fragmented, but the individuals somehow are whole. And they strive and survive in a particular American environment wherever they are. Together they form a kind of American family. Arnold Newman has given America a wonderful gift—a family album of ourselves.

FACES — An Evolution

Incredibly, FACES struck and brought to life a dormant nerve in the emotional/visual responsiveness of Americans. No one associated with the original idea of selecting the Great American Face dared predict the momentum that was immediately generated, a momentum that is still picking up speed and converts. Even apart from the enthusiasm of shutterbugs, audiences in large numbers were taken by surprise by the degree of their own spontaneous *involvement* with a display of photographs of ordinary people, "like you and me."

The original idea behind FACES was deceptively simple—although with hindsight we know now how profound it was. The idea was to enlist the interest.... No, it was far more than that: The idea was to ignite the imagination of amateur photographers all over the country. Anyone with any kind of a camera and any level of experience was invited to participate; anyone who came across a person that stirred him or her in some vital way could participate. Of course, there was a deeper purpose, which was to compile a grassroots photographic record of Americans that would mirror America's historic role of assimilation and depict her rich variety of cultures, ethnic backgrounds, and individual differences.

It was all made very easy. Significantly, "snapshots" were solicited, not "portraits." Rules and guidelines were held to a minimum: Eligible were black-and-white prints of a subject that fit any of twelve "family" categories, ranging from grandparents to babies. The hunt was on for great American faces. Almost instantly, thousands of entries came pouring in from all parts of the country.

Can meaningful photography result from such a broad-based event for amateurs? Even if the answer were No—which it emphatically is *not*—then the effort would have succeeded in terms of the sheer photographic excitement it fomented on a national level. The FACES "movement" (it cannot be described otherwise) was launched at the Kennedy Center for the Performing Arts in Washington, D.C., and then swiftly infiltrated communities throughout the nation. In a highly concentrated two-and-a-half-month period, photographic fever spread through the United States.

Cities proclaimed official Face Days, companies sponsored ingenious Face promotions, organizations of all kinds engaged in Face photographic jaunts and high jinks—all with a spirit of friendliness and elan. Cameras were trained with new interest and warmth upon relatives and strangers alike. Write-ups in sophisticated publications and small town weeklies featured the program with equal exuberance. It was lauded by the government and it became part of the Congressional Record.

Even at the outset, before a single announcement was issued and before a single shutter was clicked, everyone felt that the results *would* be meaningful, in terms of photography and in terms of providing new insights into the range of humanity in America. Assembled was a distinguished panel of judges consisting of picture editors John Durniak and Charles Reynolds, of *Time* and *Popular Photography,* respectively; photo consultant Regina Reynolds; Irving Desfor, Associated Press photography columnist; Dr. Robert U. Akeret, author of *Photoanalysis;* fine arts photographer David Finn; and Arnold Newman. They were to judge the snapshots on the basis of how well they captured the qualities of *character, personality, emotion, strength, warmth,* and *humanity.*

Out of thousands of entries, the judges selected 48 regional winners representing the 4 quadrants of the United States. From these emerged a dozen national winners coinciding with the 12 basic categories: Grandmother and Grandfather, right down to Baby Girl and Baby Boy. In effect, a "family" of winning faces came to life in each part of the country, and America had its first Great American Face family.

Perhaps that was Phase One in the evolution or transformation of FACES. The next step was to show America its own great faces—a daring concept—and then see if there were any common sparks of recognition. To get a kind of coast-to-coast reading, the exhibit went on display simultaneously in the West and East—at the California Museum of Science and Industry in Los Angeles, and at the Morris Museum of Arts and Sciences in Morristown, New Jersey. The results: record crowds. *Popular Photography* reported that "visitors to the exhibitions were moved, excited, delighted, pensive, cheered, and fascinated.... One could not help but be impressed with the fact that this assemblage of random faces [the photos] radiated

precious power. One could not help but feel that in the lines of these faces was written America's past, present, and future."

There followed endless exhibits and requests for exhibit dates in museums, auditoriums, schools, lobbies, and—with stunning poetic fulfillment—many of the nation's shopping malls, where American families derive a major portion of their sustenance. A very valuable by-product of FACES is the priceless photographic sustenance it provides to viewers. Estimates are that more than ten million people have seen FACES at malls and museums, at galleries and public places, at the National Visitor Center in Washington, D.C., and at the United Nations. The end is nowhere in sight. The United States Information Agency is conducting a three-year tour of the exhibit to 125 countries all over the globe.

Arnold Newman's contribution to FACES is inestimable. First a judge of the competition, he became a key creative force, introducing new dimensions of philosophic and photographic insight. In many ways, Arnold Newman accelerated the evolution of FACES and changed it into something resembling revolution.

For Arnold Newman's photographic statement, as well as his verbal statement in his book, constitutes a challenge to the "star" system of humanity that prevails not only in America but in other countries as well. His work forces us to look somewhat more skeptically at the entire "celebrity syndrome"— perhaps more incisively. His work unlocks the floodgates of compassion and appreciation for the ordinary people—"like you and me"—who quietly cope with their problems, and just as quietly savor their joyful moments with unheralded dignity and without artificial brouhaha. As the photographer points out, their only accomplishment is living. And that is plenty.

Only a photographer of Arnold Newman's stature could achieve this with such impact. Arnold Newman has the distinction of having photographed the truly renowned faces of famous people who, for good or otherwise, have left their mark on the world. His roster of subjects reads like a top echelon *Who's Who* (e.g., seven U.S. Presidents). To a great many of these outstanding portraits, the viewer brings captions—and that is a telling difference!

In FACES, Newman has used the camera as a kind of "equalizer." This famed photographer of the famous is saying that the ordinary people, those not "accomplished" in the usual sense, are not ordinary at all when you come to know them. They are indeed famous, perhaps *memorable* is a better word, in their own very vital spheres. He salutes and celebrates them, and invites us to get to know them through his photographs. Having photographed them, he says, "I will never be the same again and for that I am pleased."

This book represents a landmark in the evolution of photography and in the philosophy of photography. It is our hope that in some way after exposure to FACES, like Arnold Newman, you will never be the same again.

THE PUBLISHER

9

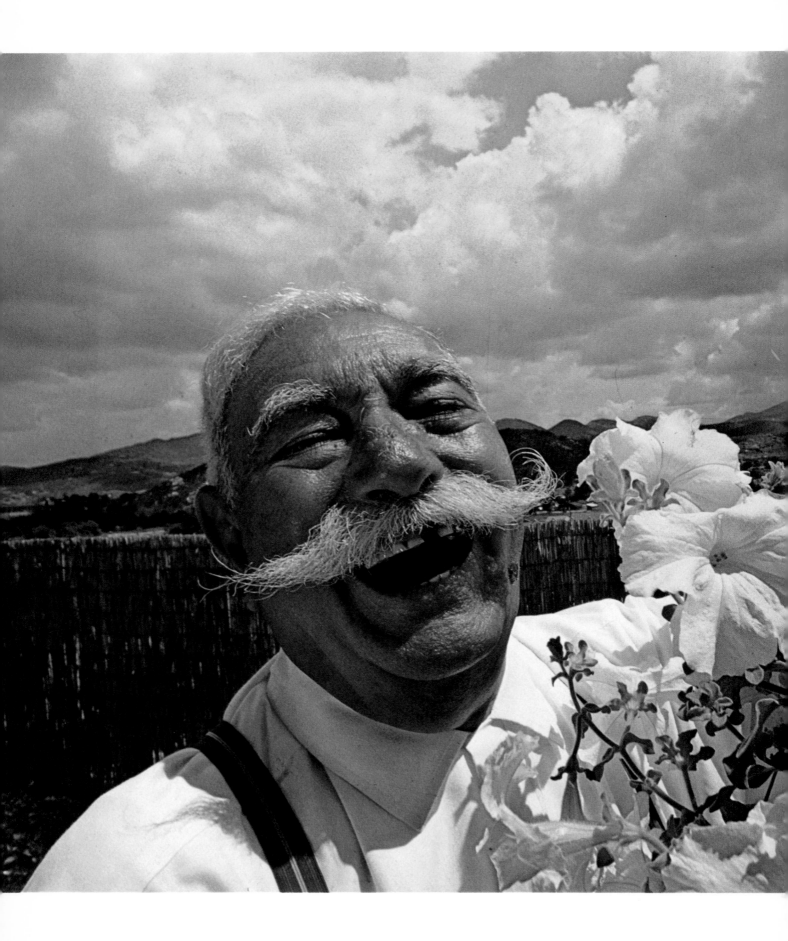

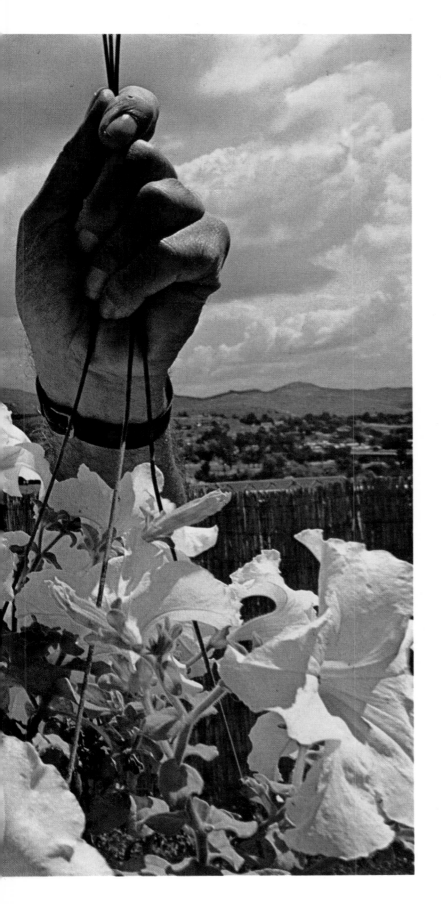

John D. Dorian (Grandfather)
Poway, California

Mark Gridley (Young Adult Male)
Columbus, Ohio

Amie Willis (Teenage Girl)
Grandview, Missouri

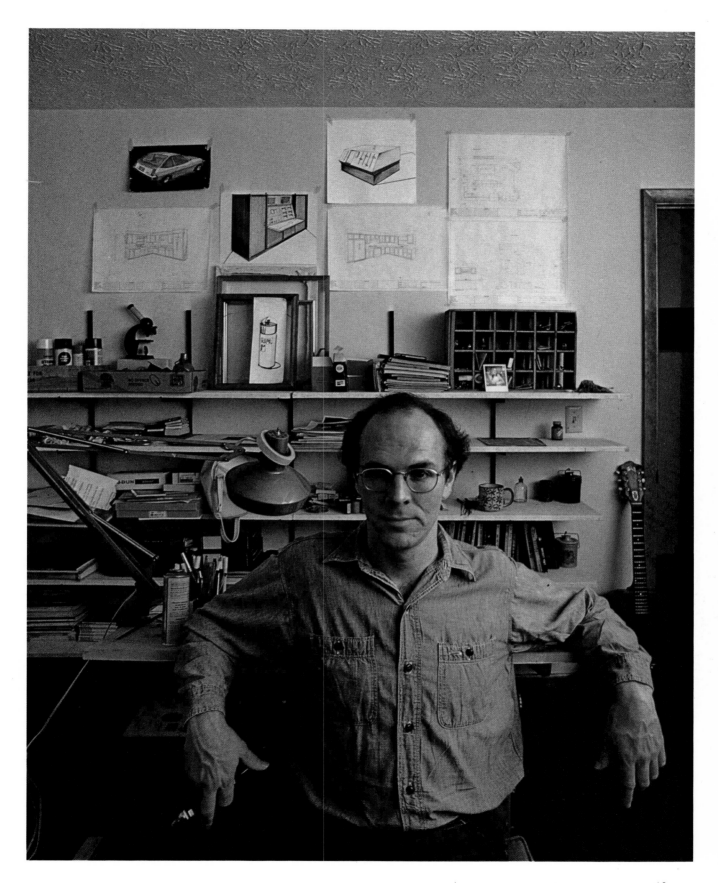

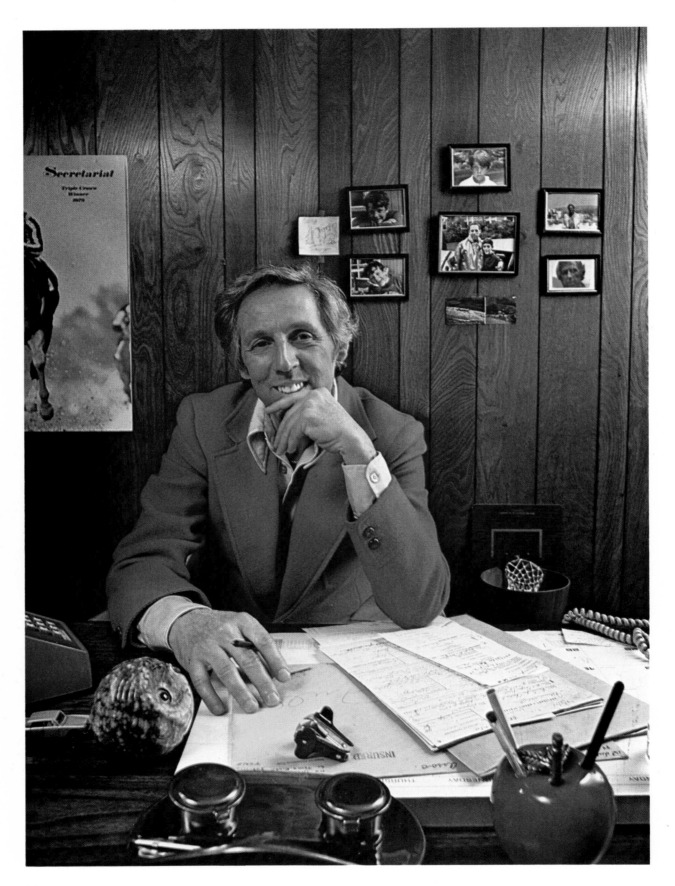

Milton Blackstone (Father)
Short Hills, New Jersey

Ruthie Scott (Young Adult Female)
Mansfield, Ohio

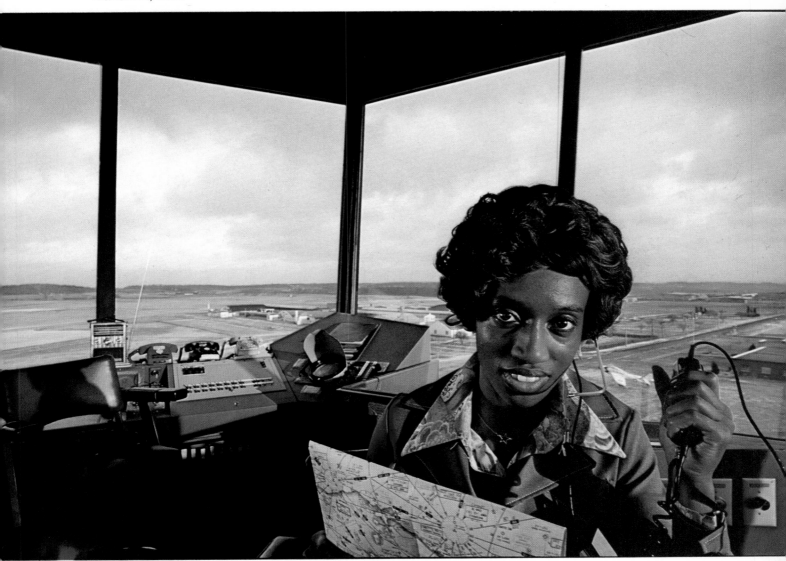

Paul Wagner (Teenage Boy)
San Antonio, Texas

Tracey Joy Schneider (Baby Girl)
Centereach, New York

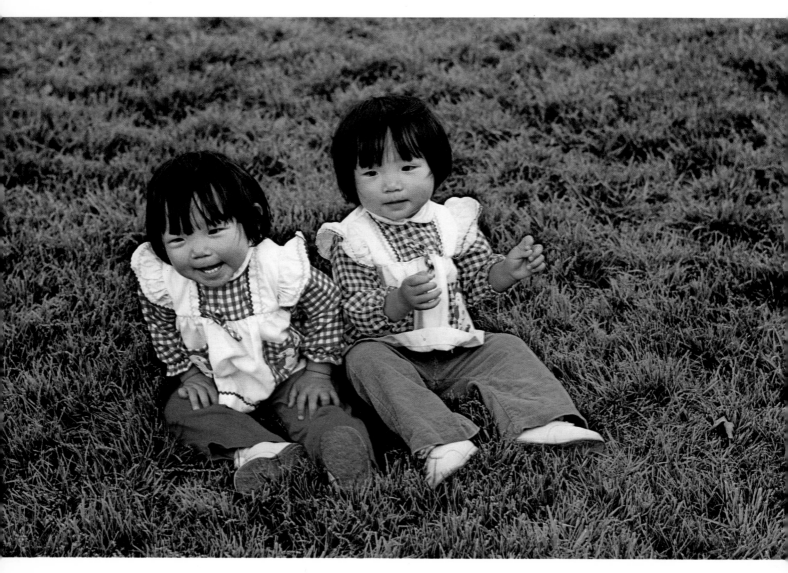

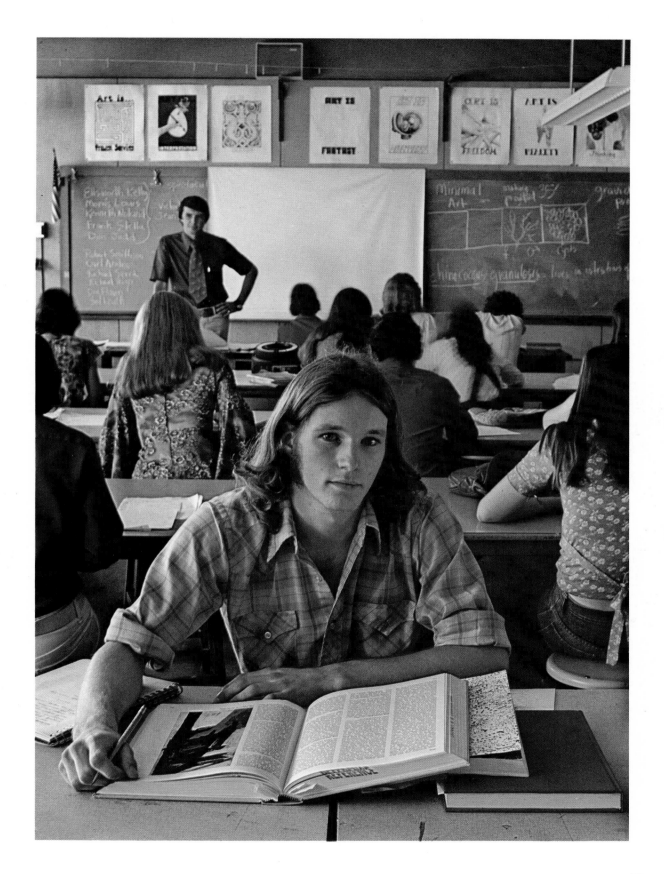

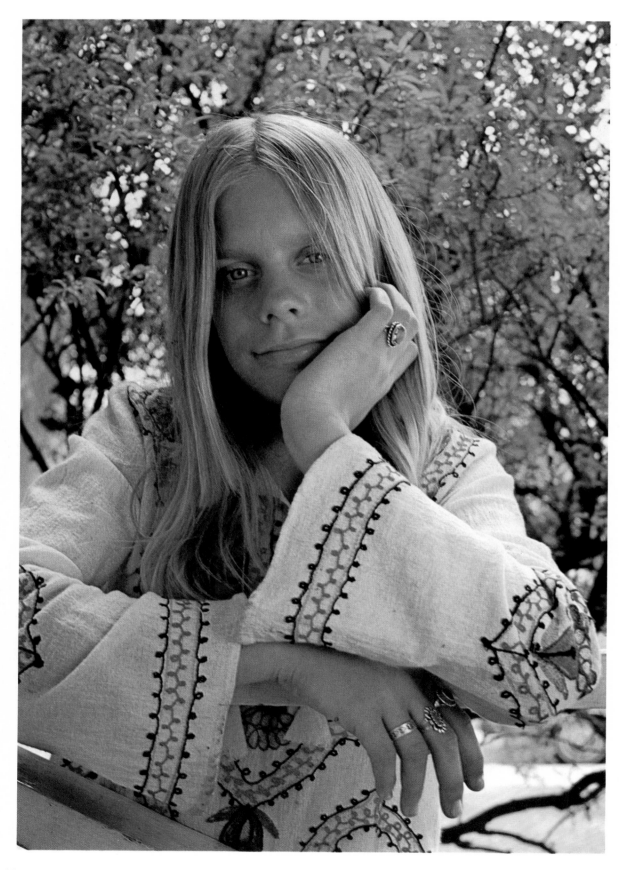

Sue Brady (Pre-teen Girl)
Westchester, California

Keziah Patterson (Grandmother)
Marshalltown, Iowa

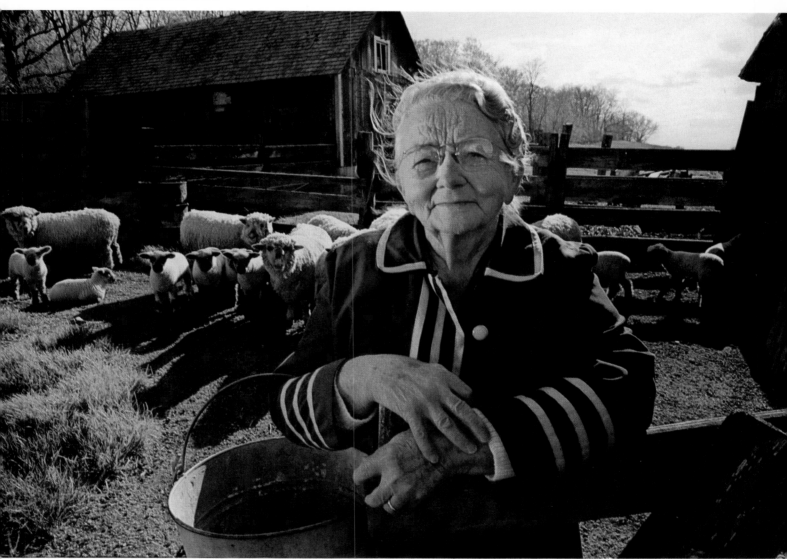

Beverly Burns (Mother)
Tampa, Florida

Jason Jardine (Pre-teen Boy)
Gaithersburg, Maryland

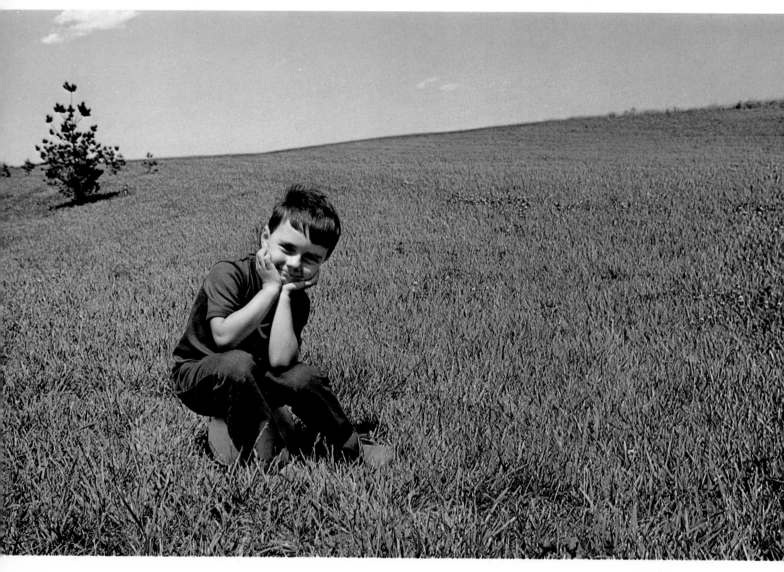

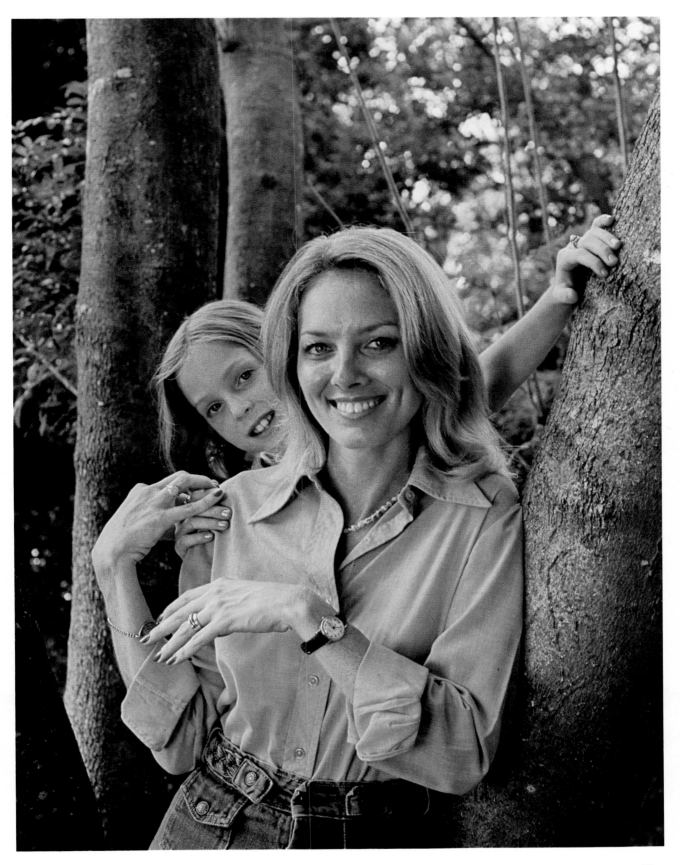

Matthew Marchese (Baby Boy)
Grosse Pointe Woods, Michigan

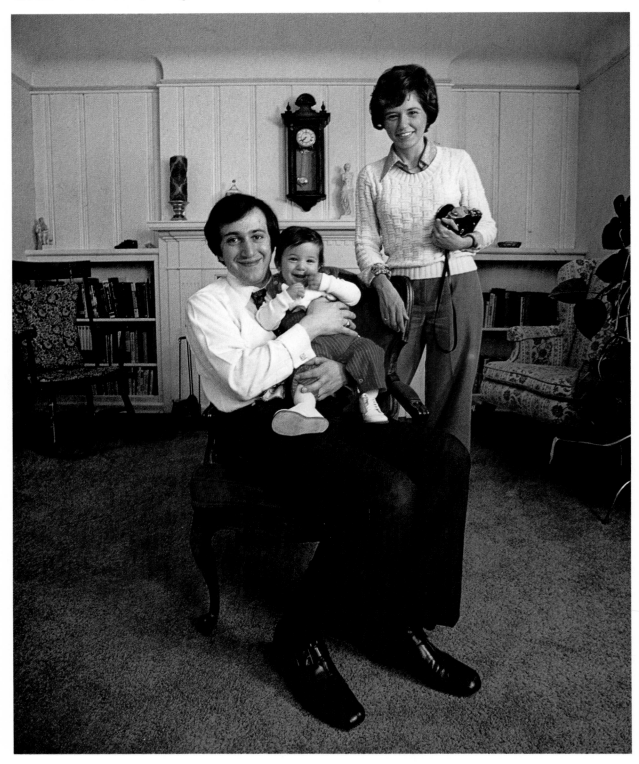

Impressions

by Arnold Newman

The wonderful people of *FACES USA* may not be as famous as so many of the people I photograph. They may not be as "accomplished" in the usual sense of that word, but they certainly are not "ordinary" people. Aside from their expected differences, each has unique qualities and strong personalities that fascinate me. Within each one there is enough material for a book, enough to unravel and probe endlessly with the camera.

I am best known for my photographs of so-called famous personalities. They are fascinating not only because of their uniqueness, but because of their accomplishments and special qualities to which we all relate. It is their accomplishments that distinguish them most and set them apart.

I am, however, intrigued by the theory that relatively speaking most everyone has the same potential at birth, and that from there on this potential is developed or diminished according to complex factors of environment and circumstance.

These *faces*—my friends in this book—are living full and rich lives. They were selected as "interesting faces" by a panel of judges who knew nothing about them as individuals. There were no captions to guide them, other than the categories of Mother, Father, Teenager, and so on. Yet the judges reacted strongly and affirmatively to their snapshot images and the qualities these revealed.

Perhaps "interesting people" is the phrase to use about those who are as accomplished in living as those who become famous for other reasons. I find it impossible, in humanistic terms, to decide which is more desirable. Perhaps this is the truer democracy— a preference for the human spirit and for its real values.

The rich character and accomplishments of "Grandfather" John Dorian impressed and moved me as much as any contact I have had with a famous politician, Nobel prize winner, or artist. He is literally a man of the seven seas, and his warm and close relationship with his family is a joy to see. The eager brightness of "Teenager" Amie Willis and her all-encompassing interests make me wonder if she will not eventually be a candidate for greatness as the world views greatness. Much more important is the inner strength of personality that is developing within her, making her the kind of person we admire and respect. It is admiration and respect that we naturally bestow on "Grandmother" Keziah Patterson, a woman who has created her own world, accepting what life has to offer, absorbing it fully, yet remaining with determination her own self completely. She is in love with life, in love with others, and strengthened by her own humor and acceptance of a changing world.

I was never bored with any of them. They were all different, some lovable, some joyous, some stubborn, moody, or withdrawn, but nevertheless, revealing. I became involved with their lives in small but important ways. I will never be the same again and for that I am pleased.

No, as I have said, they are not famous, and some are not accomplished except in living. But as my late friend, Carl Sandburg, said, "The People, Yes." I loved them. I loved photographing them ... but it did not start out that way.

At first I refused to become involved. FACES grew out of a "contest" idea. I confess I have an innate wariness of contests of any kind. In addition, it was to be sponsored by a major retailing company and would be managed by a leading public relations firm. I have often worked with industrial, commercial, and public relations firms and have, in retrospect, been pleased with what we accomplished together. But the project approach in this instance was totally different. It would involve an intimate and delicate look into private lives—and all too easily, I feared, it could become tainted by the mere fact of "sponsorship." Soon, however, the basic honesty and enthusiasm of the people involved changed my mind. The intent and project focus was similar to that championed by public broadcast television. I would have the first and final say on everything. My new associates, the Kinney Shoe Corporation and Ruder & Finn, were as interested in quality as I.

The only remaining villain would be *time*—there never would be enough. The initial and prime purpose originally was to produce a series of portraits and photo essays for exhibition at the National Visitor Center in Washington, D.C. Just as we started on the project, government requirements moved the projected

opening date from mid-August to the Fourth of July 1976. We had lost six precious weeks. No excuses, just regrets for the missing opportunity to linger and delve further in my visits with the twelve selected faces.

As a profession, the photographer's workaday world is not at all glamorous. A photographer's natural habitat is planes, automobiles, and motel rooms. There is the constant admonition: "You should have been here two weeks ago!" Worry and anxiety are a photographer's traveling companions, and torpid, irregular meals place constant strain on the digestive system. Yet it is the end result that counts—more for oneselves than for clients. Give any photographer half a chance to make photographs like these, and personal inconveniences suddenly become nonexistent.

Of course, I reacted differently to each person. The Marchese and Schneider children are young and the personalities reflected were basically those of their parents. Yet developing personalities are subtle and entrancing, and challenging to capture. In many ways, I recognized in "Teenager" Paul Wagner much of myself and many of my friends at that age. Sensitive, creative, drawn to the arts, he is trying to establish a personal style and goals in an environment that places great emphasis on sports.

I found "Mother" Beverly Burns to be an incredible woman. Ignoring the comfort that self-pity might provide, she has succeeded at home and in business with spunk and gaiety—against difficult odds.

Jason Jardine is an irrepressible imp! One minute I wanted to spank him and the next, hug him just as I did with my own sons when they were that young.

I became very concerned for and involved with "Father" Milton Blackstone. His open-heart surgery was scheduled a few days after I photographed him. I felt warmly welcomed in the company of Mark Gridley and his family. And I became enmeshed with the Brady clan and admired Ruthie Scott's determination.

Yes, each was different, predominantly eager and warm, although at times I was understandably an intruder seeking acceptance. I probed, asked questions, and sometimes became a difficult irritant to be accepted by relative strangers. I had to seek out the fabric of their lives and reveal what I could in photographs in a relatively short time.

Here are the *faces*—people who are reflections of ourselves, as they say "warts and all," but executed with love. I found I was photographing my friends and my family. They are you and I.

Notes on Techniques

by Arnold Newman

One chooses cameras, lenses, film, and lights (existing or added lights) as tools, the ones with which one can best express feelings and attitudes.

I limited the camera selection to one type, a 35mm single-lens reflex with a variety of lenses, not because it was easier but because its lightness and portability enabled me to simplify and to work quickly when necessary. The same held true with film. I limited the black and white to an ASA 400 film which could be pushed to ASA 1200. For color, I used Kodachrome II Daylight and Kodachrome II Type A Tungsten (now, unhappily, being phased out.)

This technique is common among professionals. One may possess many cameras of all types and sizes, yet the final selection is based upon specific needs. For FACES, speed and convenience took precedence, enabling me to really "live" with my subjects, taking photographs that would be lost while groping for a faster or more specialized film or camera.

Much has been written about "available" or "existing" light. Yet all professionals are faced with situations where the light conditions can mean a photograph of poor quality or no photograph at all. The solution is to augment the existing light with strobe or floodlights. I prefer the latter and used it occasionally for FACES. Strobe, while light and portable, is a constant reminder to a wary subject each time it is triggered. Floodlights, bounced and diffused against ceilings or walls, are more easily accepted as "real" light and more easily judged by the eye of the photographer. Also, more important, is the acceptance of floodlight by subjects who quickly become used to

them, reacting naturally under the bright light.

More complex is the lighting for color. The simplest technique, and closest to the beginner's experience, is shooting in sunlight, such as with John Dorian. However, a soft reflector was used for the shadow area, which otherwise would have been much too dark. Strobe would have appeared artificial, and under the circumstances, would have been less controllable. Paul Wagner and Milton Blackstone were photographed with tungsten film and with floodlights softened by bouncing them off white bed sheets (carried for that purpose) to avoid reflecting the color of the walls and ceilings. The exposures were from one to two seconds with the camera on a tripod.

Paul Wagner's classroom is usually lit with window light and fluorescent lamps, an almost impossible mixture to filter correctly. I selected the window light because it was a natural and a better "creative" solution. The deep shadow on the side of Paul's face was opened with a small light equipped with a blue filter balanced for daylight. The exposure was about two seconds, which added another technical factor, reciprocity—the shifting of both exposure and color factors when the exposure of a film deviates from the built-in "norm."

However, the solution of the reciprocity problem and all the other problems a professional photographer faces must soon become automatic, or at least he should be well informed and prepared so that he can face them without distraction. The *real* problem is the photograph—the photograph that reflects his ideas and concepts about both his subject and photography.

Jason Jardine (Pre-teen Boy)

Gaithersburg, Maryland

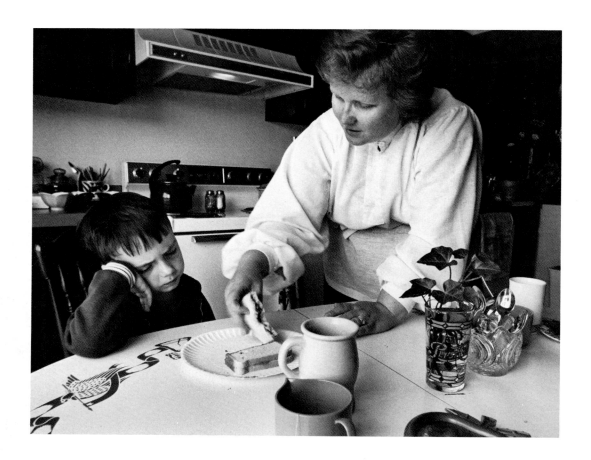

Jason, age 5½, has more expressions per square inch of face than anyone you have ever seen. A constant parade of delightful looks, grimaces, gestures, and smiles flicker across his face like the play of light on water. Only the keen eye and fast lens of Arnold Newman could capture Jason's many moods.

Jason's dad, Carl, is a fireman. Jason loves to visit the firehouse in Washington and shows up quite often. At home, they're putting the finishing touches on a fairly elaborate set of model trains in the family room where Jason

has his own workbench. He has a real desire to understand how mechanical things work.

According to his mom, Valerie, he is, by turns, impish, outgoing, competitive, adventurous, and an organizer, yet cooperative and understanding. At 4½, Jason's stated goals were "to tie his shoes" and "read." One year later, he has accomplished both but now wants to "learn all about nature." Perhaps stimulated by "Emergency" on TV, he's now quite sure he wants to be a paramedic.

Jason's best friend is Jeffrey Garfinkel.

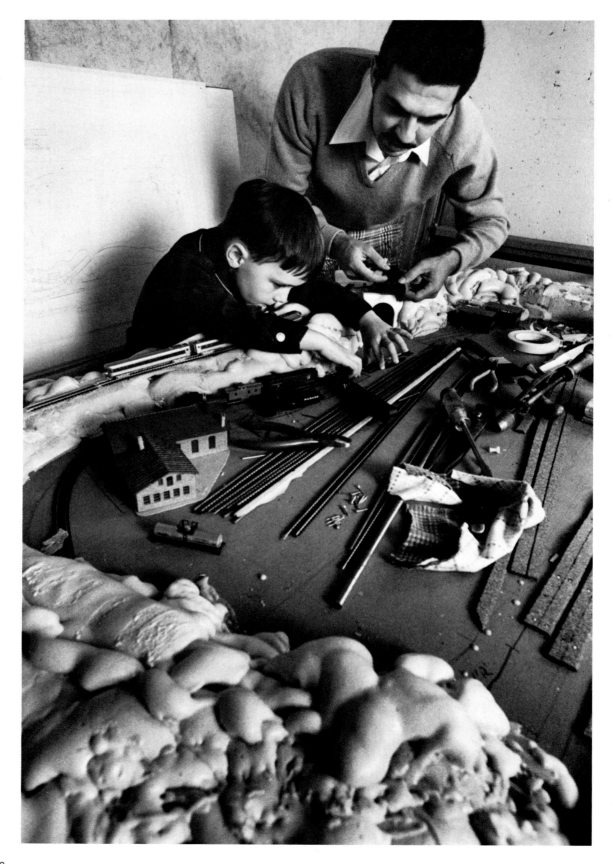

28

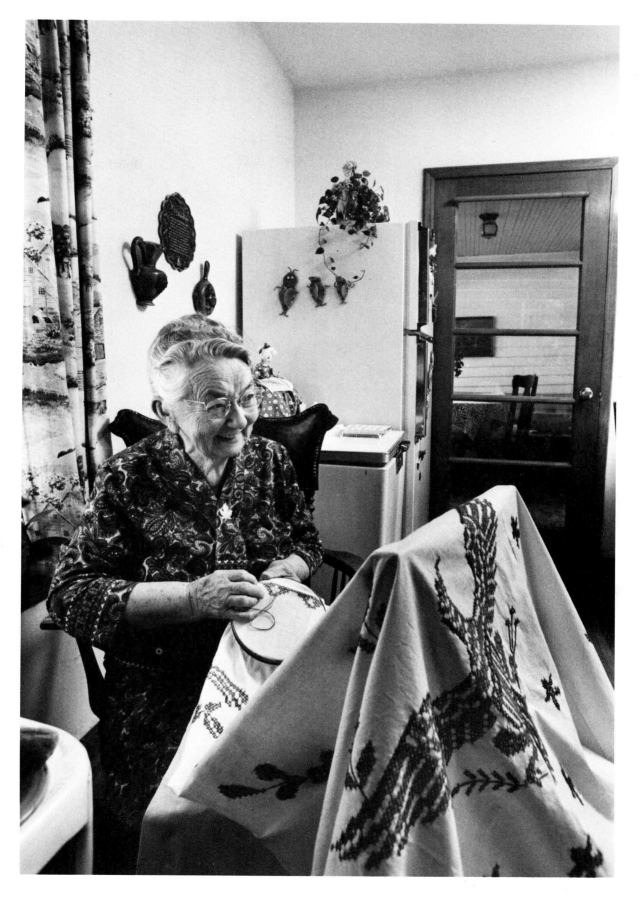

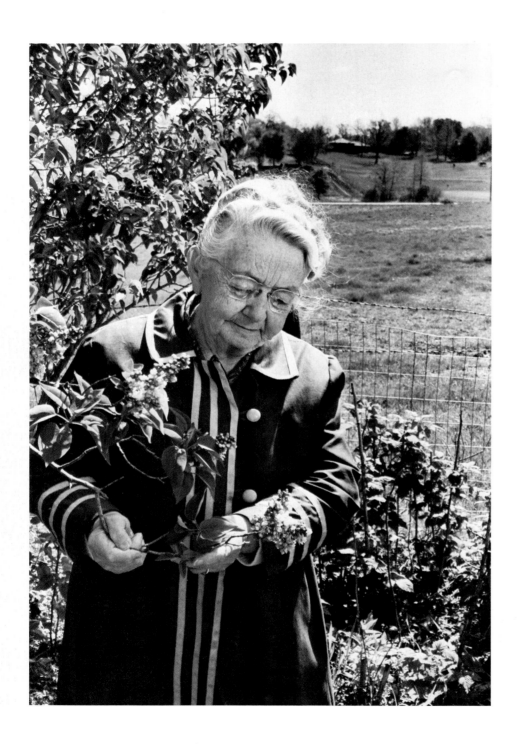

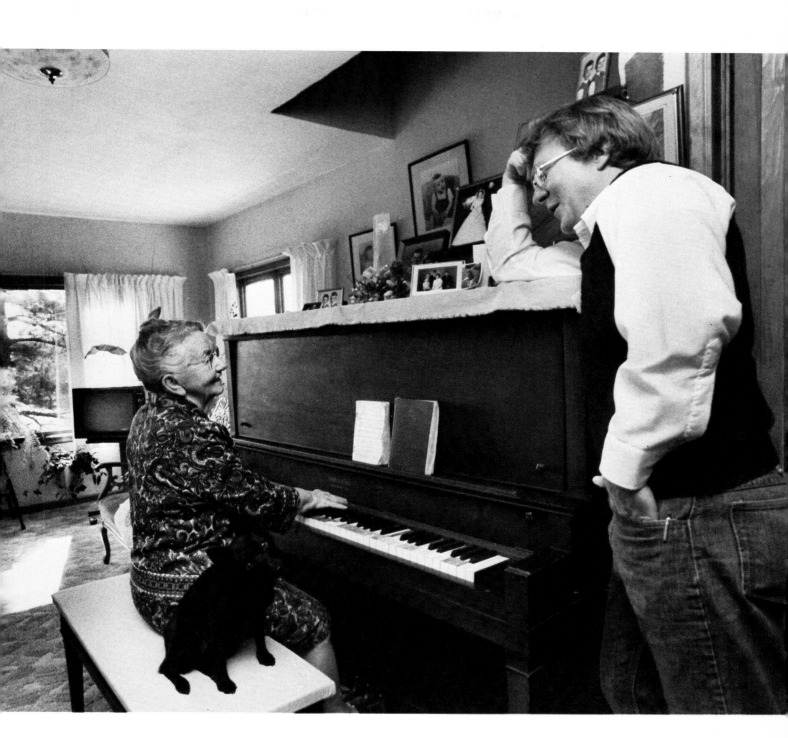

Mark Gridley (Young Adult Male)

Columbus, Ohio

Mark shares a town house apartment with his brother Kurt. His bedroom doubles as a design studio for his personal work. An industrial designer with a Bachelor of Arts degree, he currently works in an art gallery and frame shop. His ultimate goal is to become a top-flight automobile designer.

His parents live in Delaware, Ohio, where there are frequent family reunions, usually featuring a hearty buffet dinner and good conversation. The family dog, Danny, is a golden retriever. His girl, Mary Slyby, who took the winning photograph of Mark, shares his aesthetic interests. On Sundays, they both enjoy visiting the Columbus Gallery of Fine Arts.

The outdoors holds a powerful attraction—sports, walking, camping, skiing, and fishing are pursuits Mark thoroughly enjoys. He also plays the guitar and wants to learn piano. "America is a place of fantastic opportunity, offering a tremendous amount of freedom, and it's a great place to live."

Being named a Great American Face sparked Mark's imagination. He talks about "being a contributing member of society, a source of good will toward others," and of striving to create beauty that is also functional.

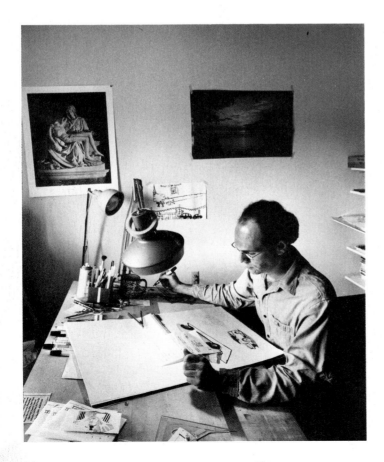

41

Amie Willis (Teenage Girl)

Grandview, Missouri

Amie is an extraordinarily versatile teenager. She does everything with a great deal of enthusiasm, whether it's taking part in band practice at Grandview East Junior High (She's a talented flutist.), playing team chess, or developing her own film in the school darkroom.

Amie enjoys growing plants and hanging them in the bedroom using her own handmade macramé potholders. An outstanding student, she also writes for the school paper, serves on the Student Council and yearbook staff, and writes poetry. Last year she received a Good Citizenship Award on the basis of her leadership, talent, personality, and general well-roundedness.

Athletics receive a fair share of the Willis style and stamina. She bowls, plays tennis, and is a regular on the South Suburban Junior Athletic Association basketball team (at 13, she was already 5'9"). Amie also enjoys an occasional romp on her front lawn with her regal schnauzer, Oscar.

She describes Troy, a constant companion, as a "really good friend." Her mom, Edith Stowers, is a computer operator, and her stepfather, Joseph Stowers, is a painting contractor. Another important person in her life is her brother, Ridge Willis.

Amie leans to a teaching career, preferably math in a junior high. She calls herself Grandview's "biggest smiler," adding: "My favorite thing is people, I just love people."

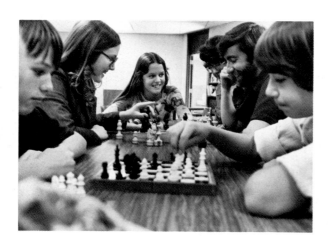

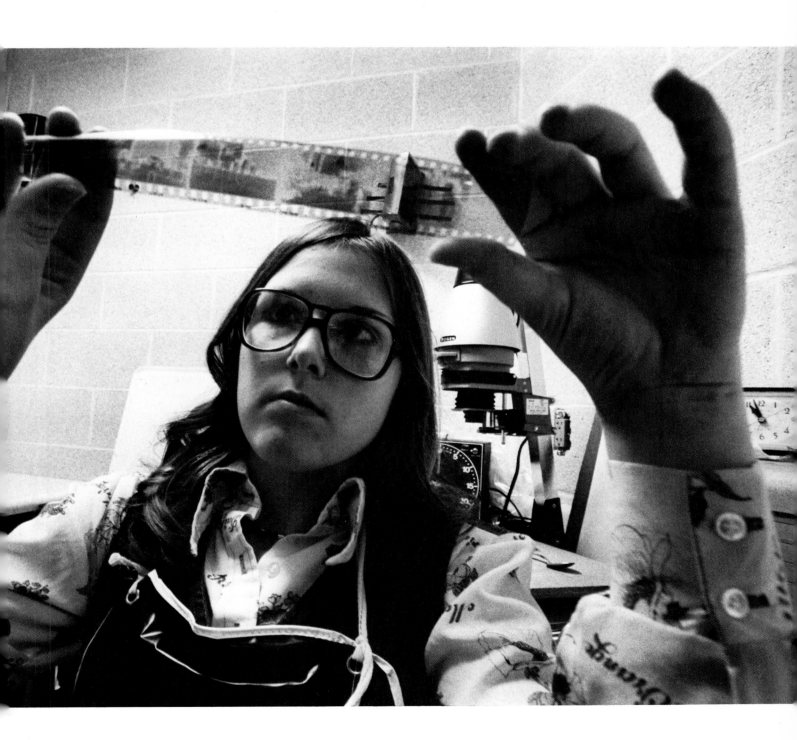

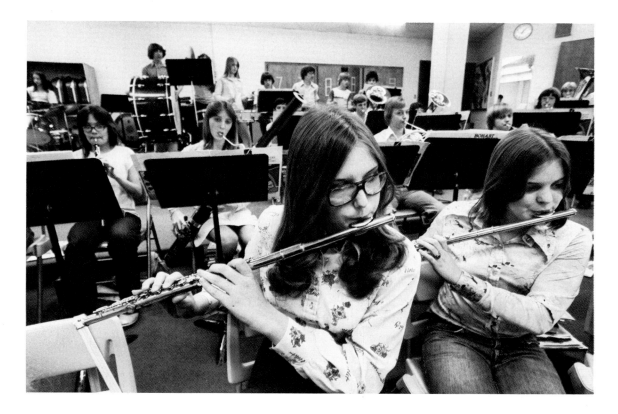

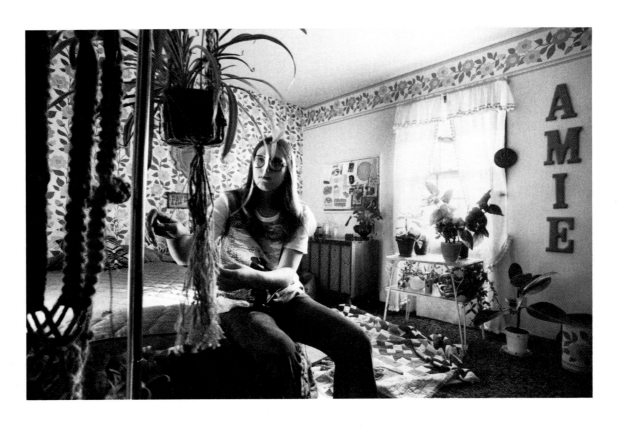

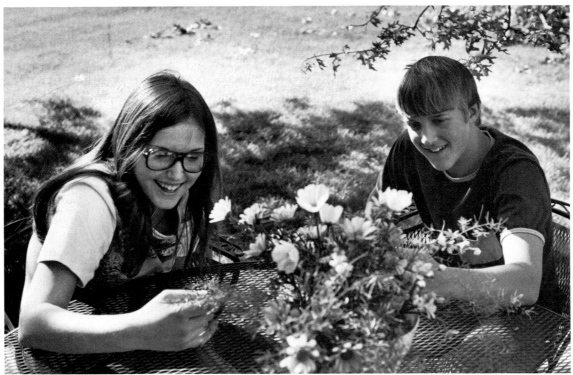

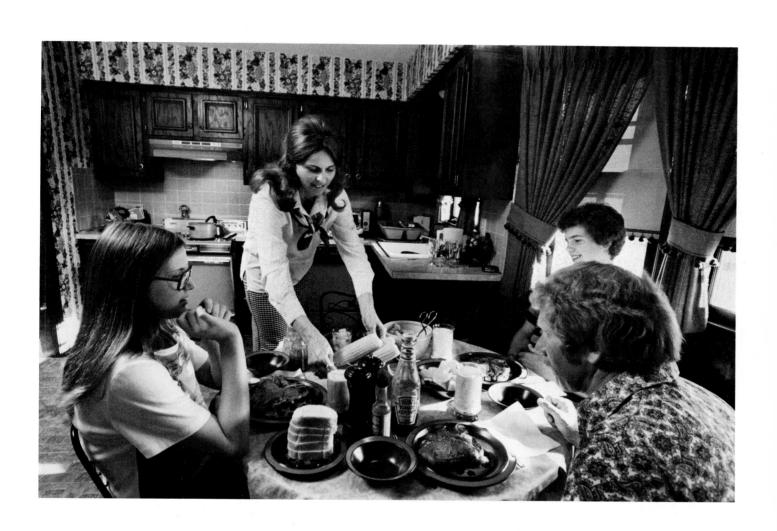

Milton Blackstone (Father)

Short Hills, New Jersey

Milton was scheduled for open-heart surgery a few days after these Arnold Newman photographs were taken. "It was extraordinary to me," Newman marvels, "that this man put our needs ahead of his own personal situation at such a grave moment of his life."

With the operation successfully behind him, Milton, a financier, is again taking an active role in his business. His office staff is "like a family," and he is proud that most of them have been with him since the beginning.

These photos are filled with the drama of the days prior to surgery, with family and friends rallying around to wish him well. A neighbor took the winning photo while they were on vacation. Milton was amazed that he was caught smiling by the camera. "You know," he joked, "businessmen don't smile." But, he admits, he's been smiling ever since he was named the "great American father." "I'm having a ball with it."

A football fan, he enjoys practice sessions with his son, Glenn. His older boy, Robert, is studying law. His wife, Dorothy, has been the greatest influence in his life.

Contacted about his photographic honors, his first reaction was: "It's a good gag." Then he said he felt "very good." "People of any ethnic background can achieve their goals in America." His wish is that his children, and all children, have the same opportunities he has enjoyed.

54

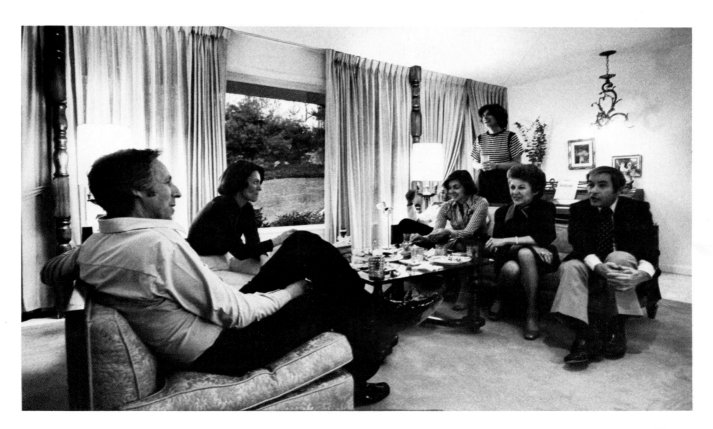

Ruthie Scott (Young Adult Female)

Mansfield, Ohio

Born in Watts, Ruthie Scott has advanced, with the help of government-financed education and on-the-job training, to a responsible position in the field of air traffic management. She was the first woman air traffic controller hired at Mansfield's Lahm Airport and aspires to become chief of a tower someday.

Her Great American Face was spotted by an alert passenger who was reading about the contest that very day in the local paper—a dashing photograph of the gregarious air traffic controller resulted.

As Arnold Newman set up his camera in the tower some months later, there was a sudden power failure. Ruthie was again photographed working in earnest rather than role-playing for the camera.

A devoted mother, Ruthie makes sure her five-year-old son, Gerald, pays attention to his school work. He has an expanding fish collection and, enjoys sports, particularly bowling.

Ruthie points to two years of college and a year of business school as critical factors in her development. She has returned to Watts with new personal goals and a determination to succeed.

Reflecting on the opportunities America has afforded her, she concludes: "Most importantly, I get a chance to be me, to express my own opinions and to vote the way I want."

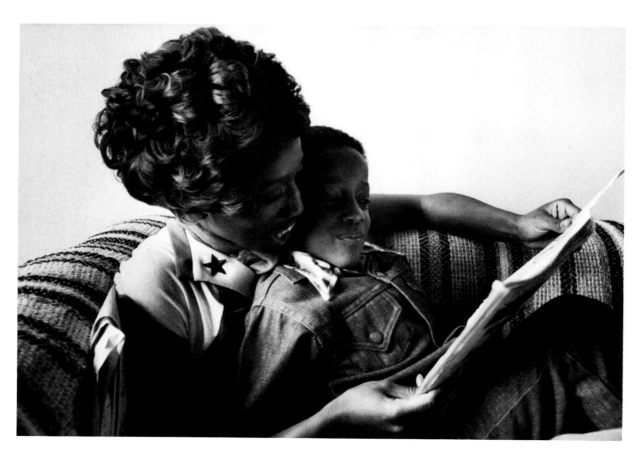

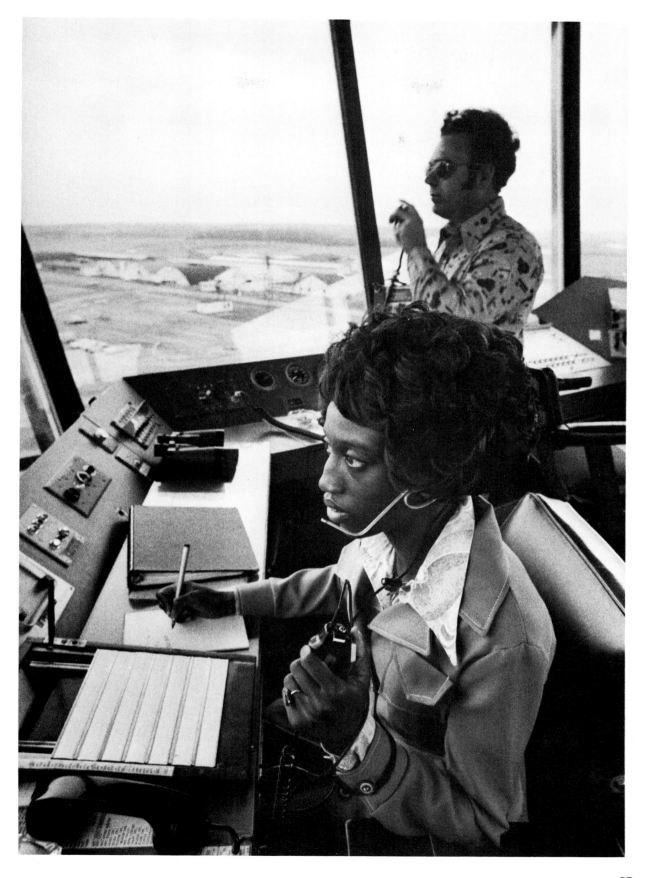

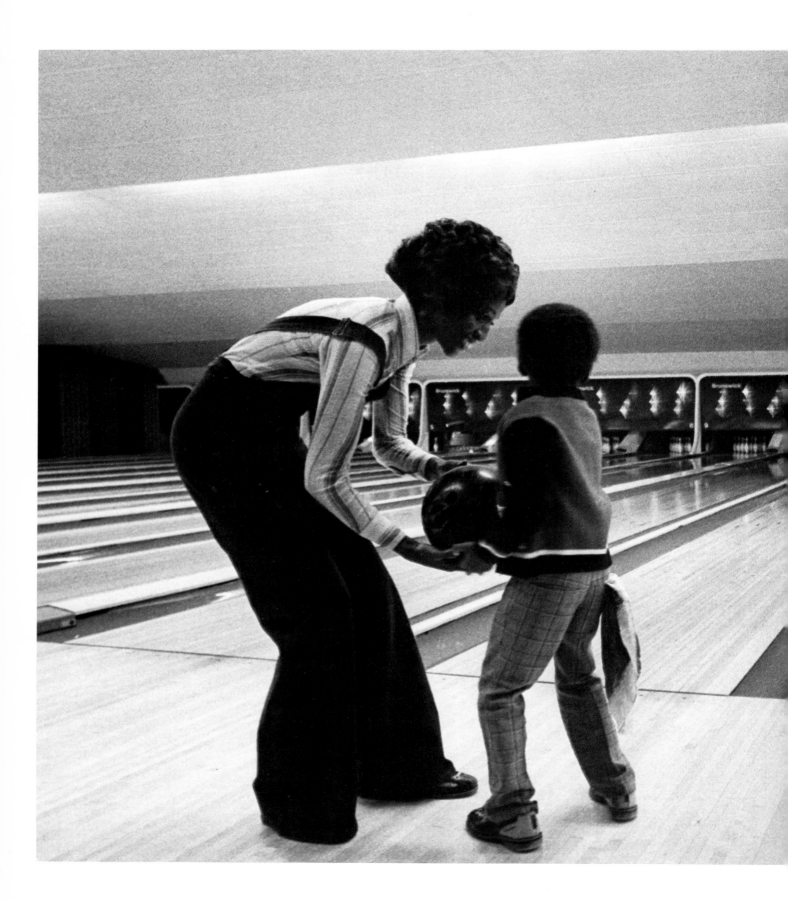

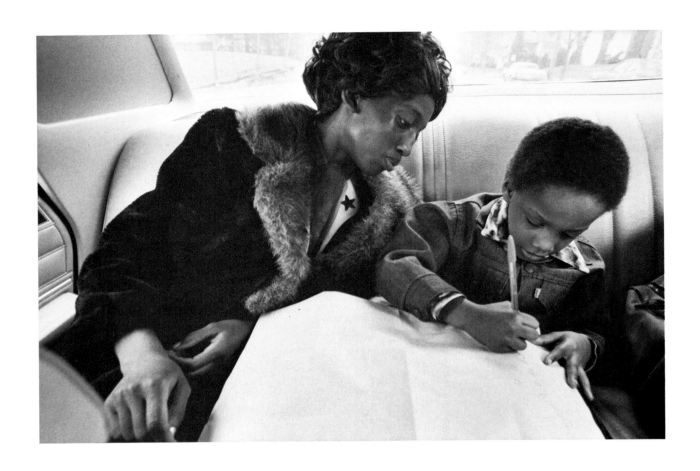

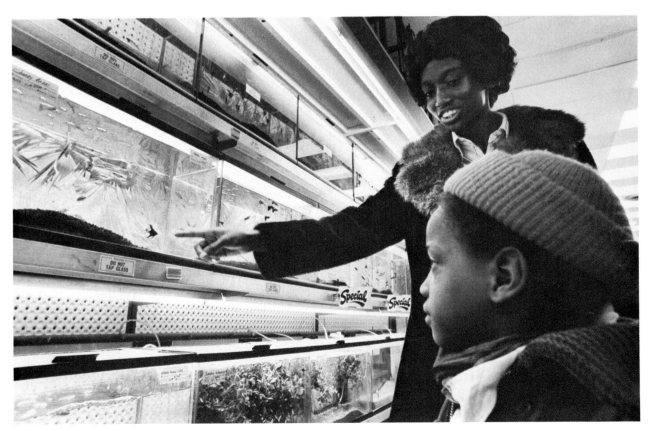

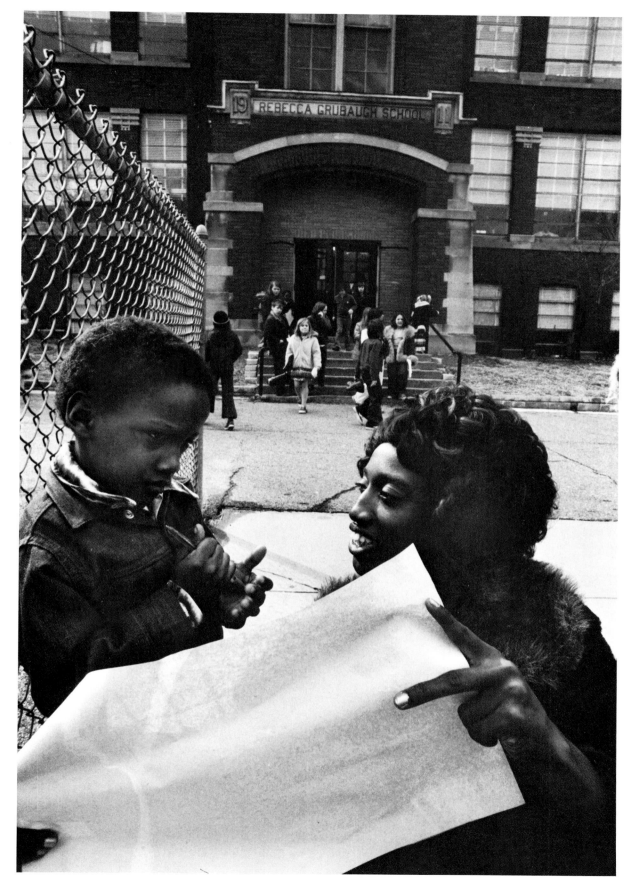

Matthew Marchese (Baby Boy)

Grosse Pointe Woods, Michigan

"If you've seen one baby picture you've seen 'em all," is a view held by many of us, especially if the subject happens not to be a relative. But little Matthew Marchese's unique expressiveness would set him apart in any company. By unanimous decision of the judges, he became one of the Great American Faces, at age six weeks.

Marie Marchese took the winning picture of her grinning son. "The smile on his face was not hard to get. He is usually smiling and has a good disposition." His father, Paul, a sales engineer, says, "He's a ham and loves having people around him."

Having passed the milestone of his first birthday quite unaware of the adulation of his fellow Americans, he once again found himself caught up in the camera game, this time with world-famous photographer Arnold Newman. The occasion called for a gathering of the Marchese clan with Matthew's relatives, some 30 strong, in joyous songfest at a pizza party around the family table. Both sides of the family tree are represented in the group photo, with uncles, aunts, cousins, and grandparents surrounding young Matthew, who seems alternately blasé and delighted. Grandfather Adolph Bufalini gently serenades the boy with his guitar.

Then lights out, with Matthew's best shoes leading the way to dreamland. For the rest of the family, it is time for warm recollections of a busy day.

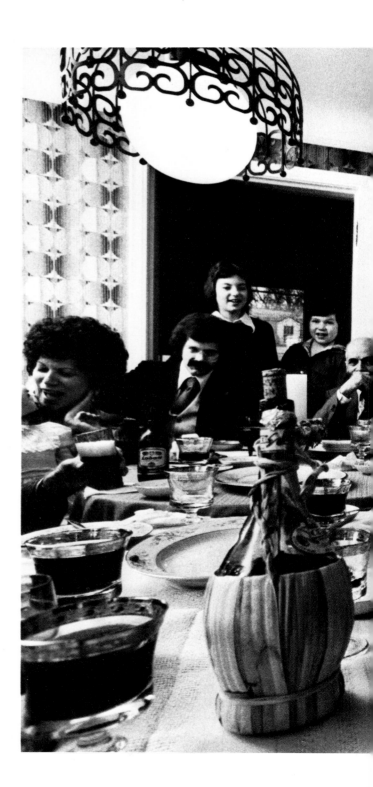

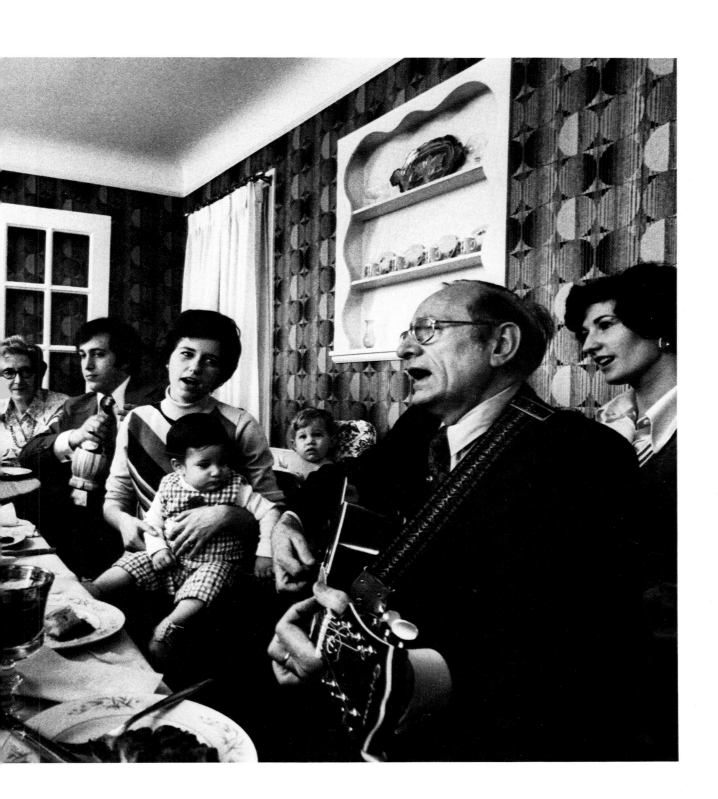

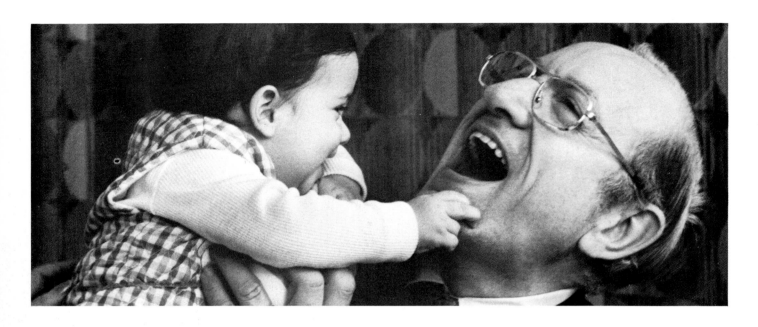

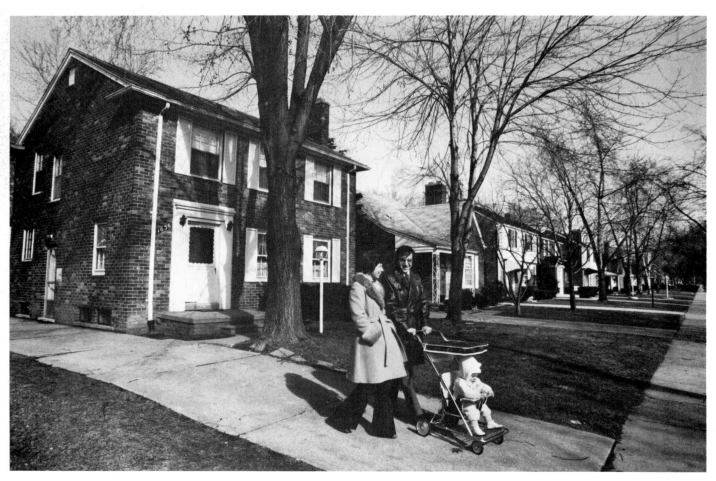

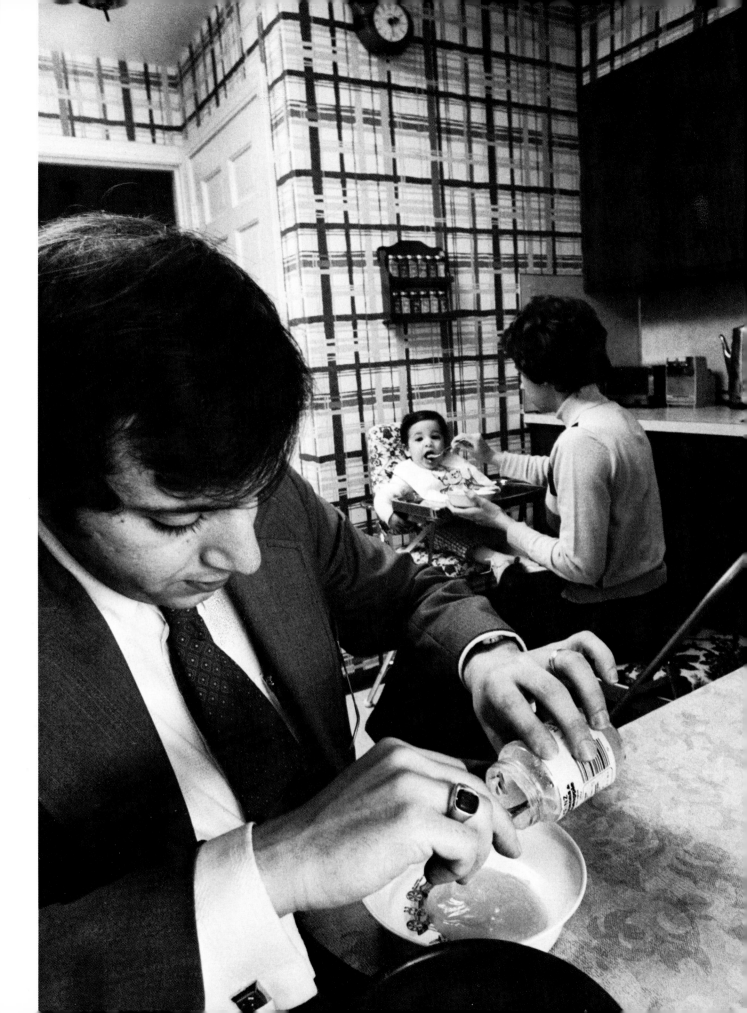

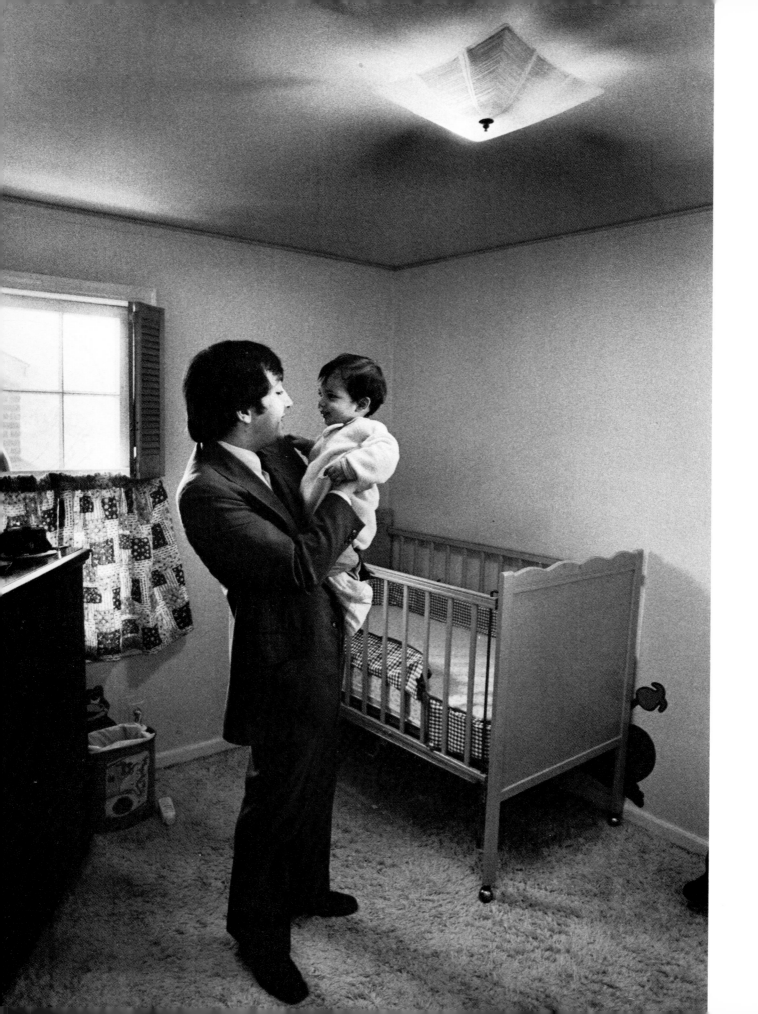

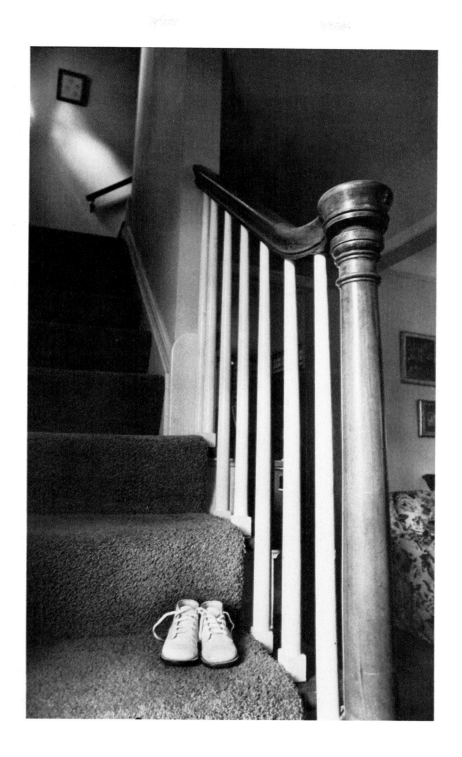

Beverly Burns (Mother)

Tampa, Florida

"To be happy—and face reality" are Beverly's personal goals. She has reached a point in her life where she is achieving both. More than six years ago her doctor told her she had multiple sclerosis, which is now in a state of remission. Overcoming her illness was an uphill battle that she was determined to win. Support came readily from her parents, four sisters, and especially from her husband, Bill. Apart from some daily fatigue, Beverly is winning her battle. Arnold Newman photographed her from morning till night and found not a trace of self-pity. Instead, she jokes about the problems MS causes her and has even become an MS fund-raising volunteer.

She shares with her pixie-like daughter Carmen, age 7, the fun and skills of needle-point, ceramics, cooking, and sewing. They often enjoy short bicycle trips in the neighbor-hood. Beverly and Bill are art enthusiasts, and together they are making a go of their shop, The Frame Factory, just a block away from where they live. They built the store from scratch and made a success of it in one year. Beverly, also talented in graphics, handles the commercial side of the business. She deals with interior decorators, hotels, and doctors' and lawyers' offices.

The winning photograph of Beverly, a family favorite, was taken by Bill with a brand-new camera at a picnic on their very first date. A large blowup of it is framed and proudly displayed in their shop.

Beverly dislikes petty gossip, erroneous ideas about handicapped persons, and people who call children "brats." The beauty of America, she says, is that it allows "the freedom to make changes."

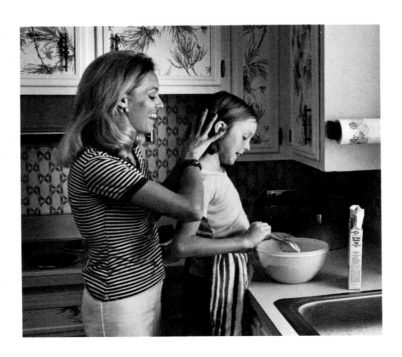

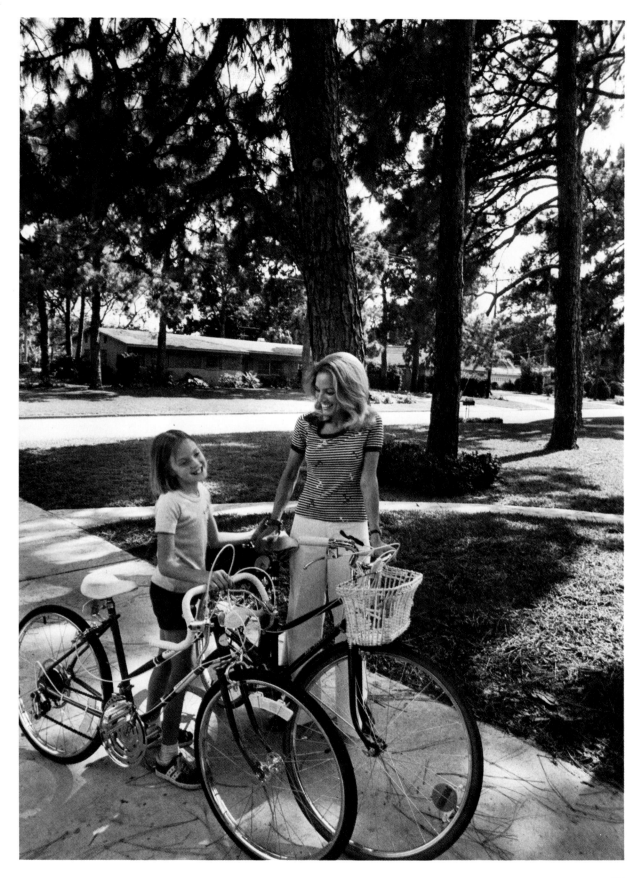

Paul Wagner (Teenage Boy)

San Antonio, Texas

Paul Wagner, age 17, gives renewed meaning to the term "all-around." A competent photographer, painter, guitarist, and good student, he is included in the John Marshall High School's *Who's Who*. He is also a good track man and knows his way around the state park camping scene.

Paul lives on the edge of the picturesque Texas hill country. His girlfriend, Janet Beam, frequently accompanies him to the banks of a tree-shaded stream in Raymond Russell Park. His dad, Paul Kenneth, is an insurance executive. His mother, Theo, has a diversity of interests, many of which coincide with Paul's.

The Wagners are all sports enthusiasts to some degree, and often gather to watch major events on television. Often joining Paul are his brothers Boren Lee, 19, and James, 22.

School is the center of his existence. A teacher who has had great influence on his life is Ward Sanders (which explains his prominence in the Arnold Newman portrait). Paul credits Sanders with "developing my creative talents." His ambition is to become a self-sufficient artist. People and abstracts are his favorite subjects. Paul works summers in the kitchen of a popular restaurant in nearby Leon Springs.

Being able to get along with people is important to Paul. Good friends, who understand each other, make him happiest. He would like to see "equality for everyone."

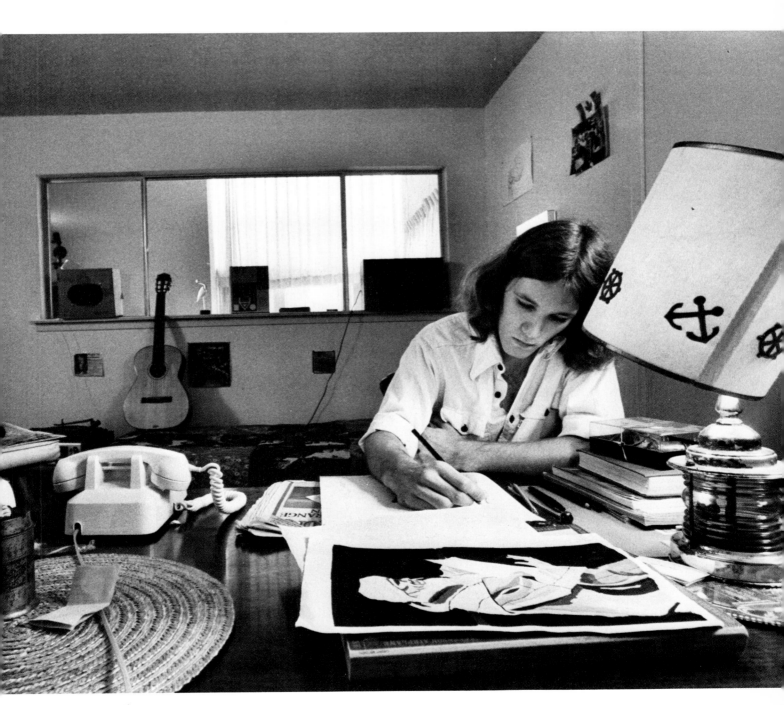

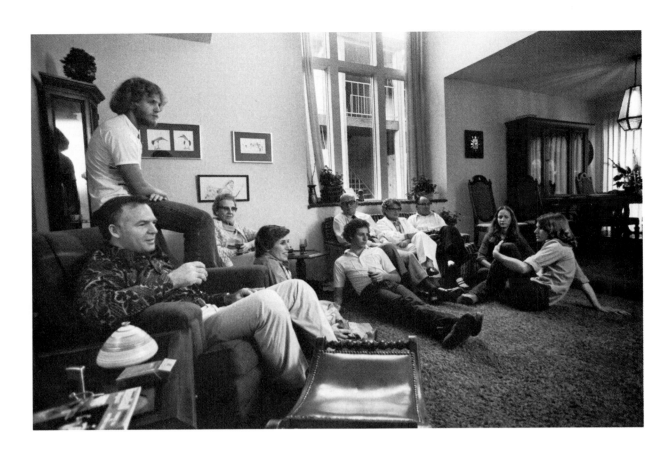

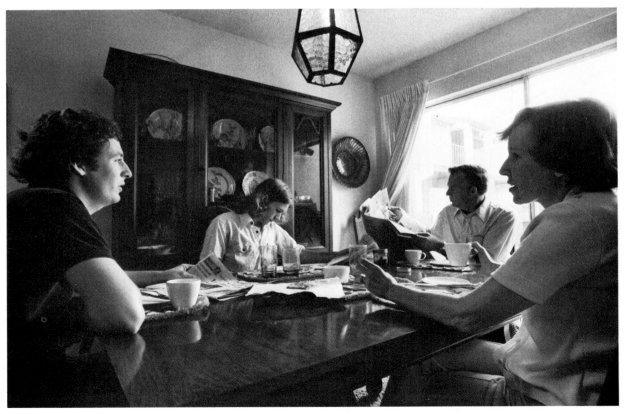

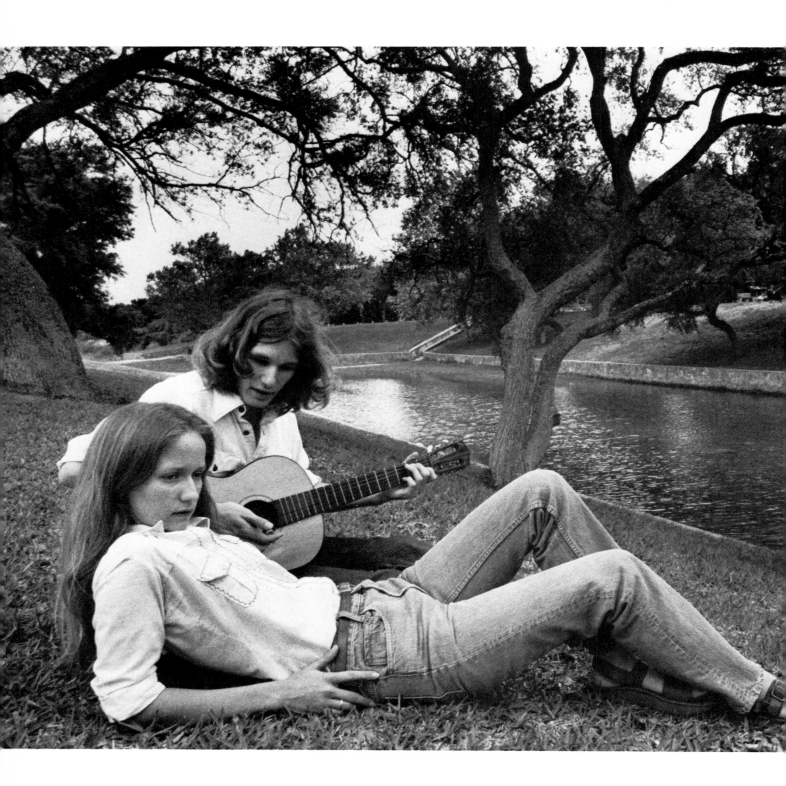

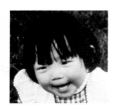

Tracey Joy Schneider (Baby Girl)

Centereach, New York

Imagine everyone's joy when one of the Great American Faces turned out to be a *pair* of Great American Faces shown in Arnold Newman's portrait. (Tracey is on the left.) The original winning snapshot was actually a split image, showing one face (instead of the twins) to conform to contest rules: "One face per snapshot."

The bouncing baby Schneider twins, two bundles of boundless energy, are adopted Korean tots who are all but impossible to tell apart. "They have taken to American ways like ducks to water," say their parents Joseph and Elissa, an engineering technician and registered nurse, respectively.

It takes all of my professional know-how to keep them on even keel throughout the day. They want to do, and be a part of, everything," Elissa admits, but her patience is as inexhaustible as her love.

"We do things together, whether it's feeding the 'quack-quacks,' romping at the beach, enjoying the swings, or watching TV. They're regular little acrobats, constantly getting into mischief," Elissa adds. "Our two pet dogs make for additional merriment—and work."

The twins are a little shy with strangers. It took them about half an hour to warm up to their photo sessions with Arnold Newman. When they finally did, however, toys came out from all directions and suddenly, Newman recalls, "there were marvelous pictures everywhere."

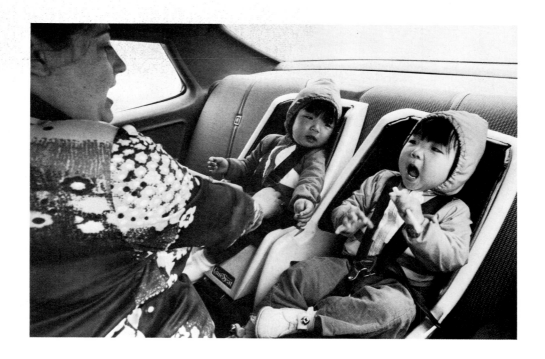

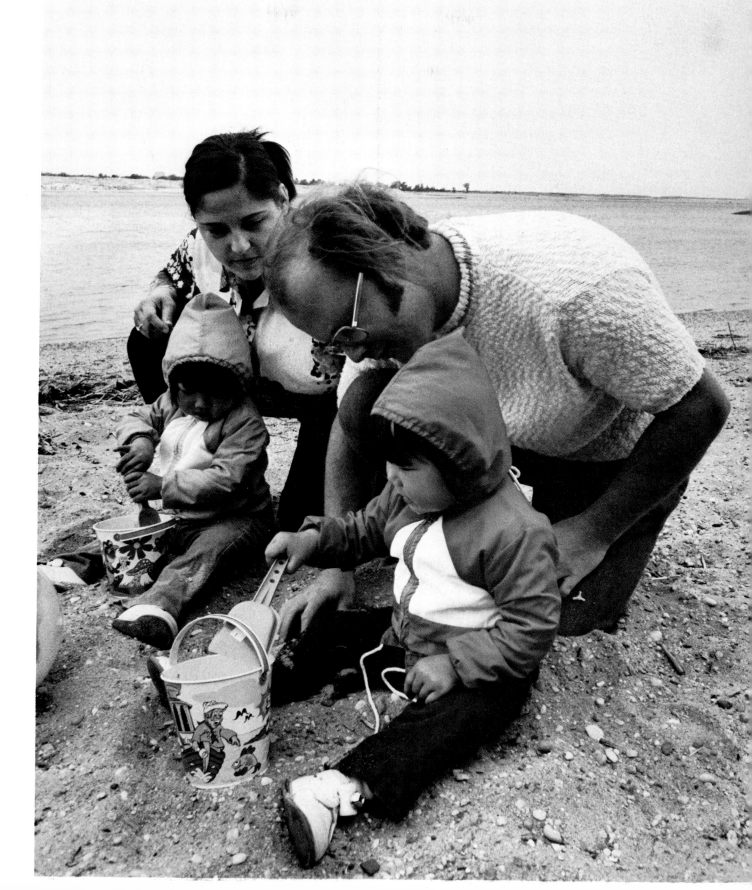

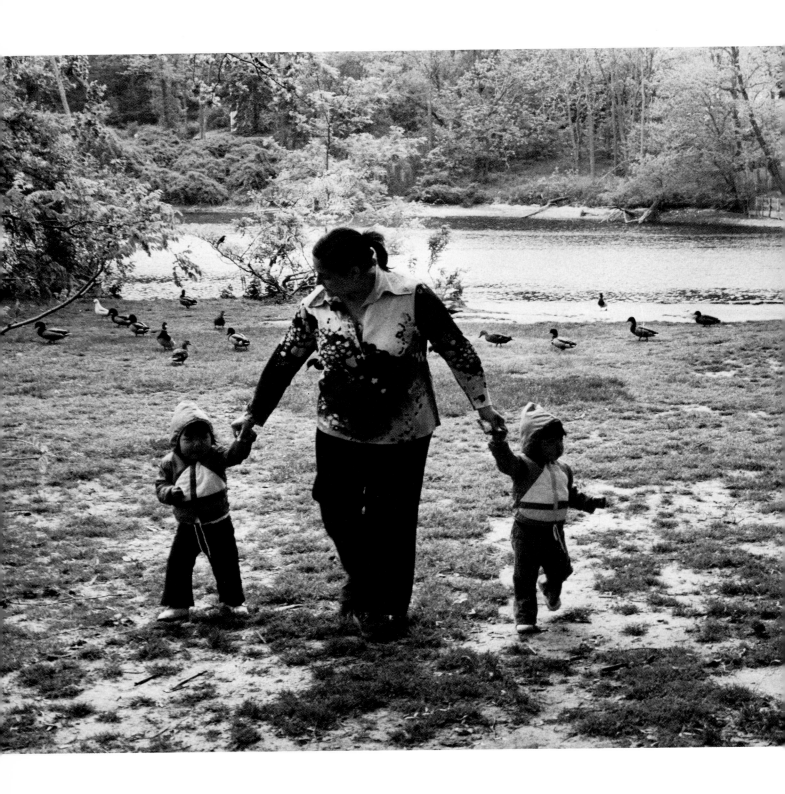

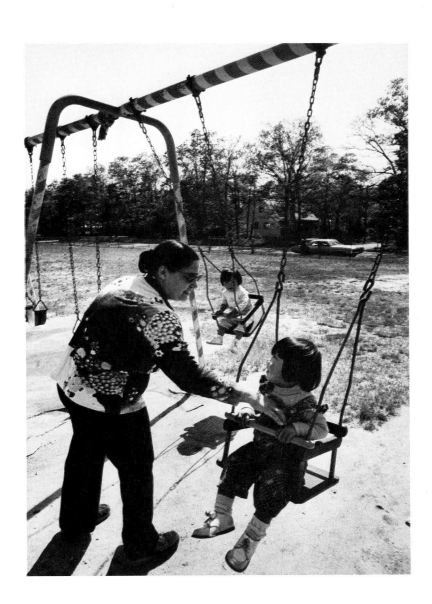

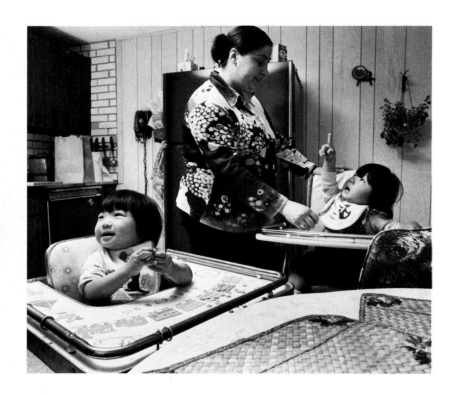

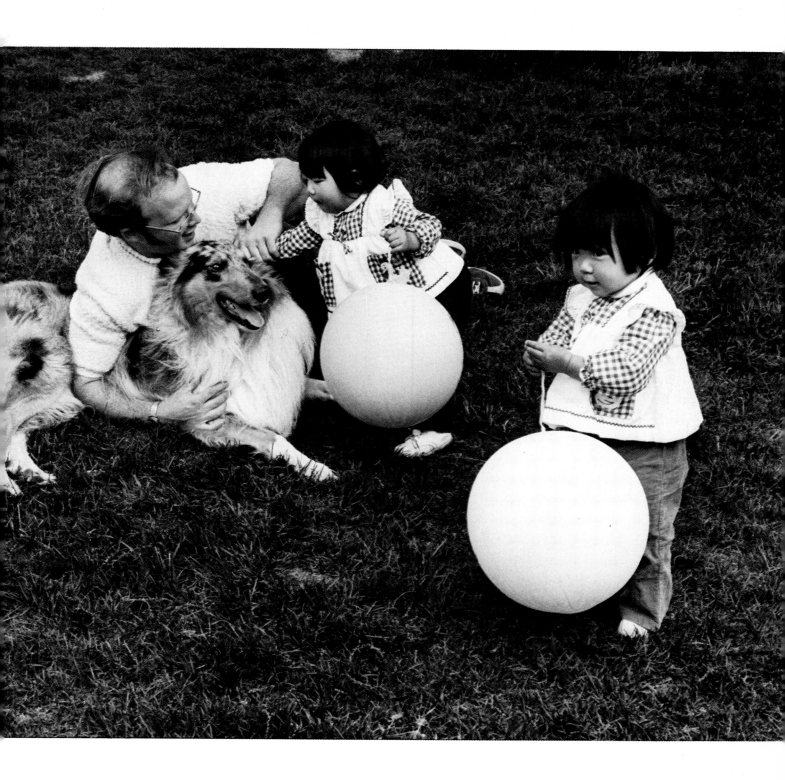

Sue Brady (Pre-teen Girl)

Westchester, California

The maturation of Sue Brady, age 13, in the space of less than a year from the time of her "winning" photograph to her photo session with Arnold Newman was both subtle and striking. "I went out expecting to photograph a little girl and found someone much more grown up," Newman relates. Today's Sue is an appealing blend of childlike interests as well as some very real adult attitudes.

The Newman color portrait was posed on the front porch of Sue's house in a surburb of Los Angeles.

Her rather large family includes two sisters and three brothers who apparently get along well together, thanks to the steadying influence of their mother, Betty Wright. Dad, Frank, is an engineer.

Sue is an avid bicyclist, loves to ice skate, and enjoys water sports. She spends a good many hours drawing automobiles and busy scenes in her room, which is shared with a younger sister. She hankers for an art career, but thinks "it would be really neat to be on TV." She is adept at macramé and her mother is gradually instructing her in the practical aspects of sewing on the family machine, which sees heavy duty throughout the year.

When asked what makes her happiest, Sue replied, "When people are nice to me and they don't interrupt when you're talking," which is probably indicative of a growing sense of self-esteem and self-confidence. Her wish for America is that it "help stop wars."

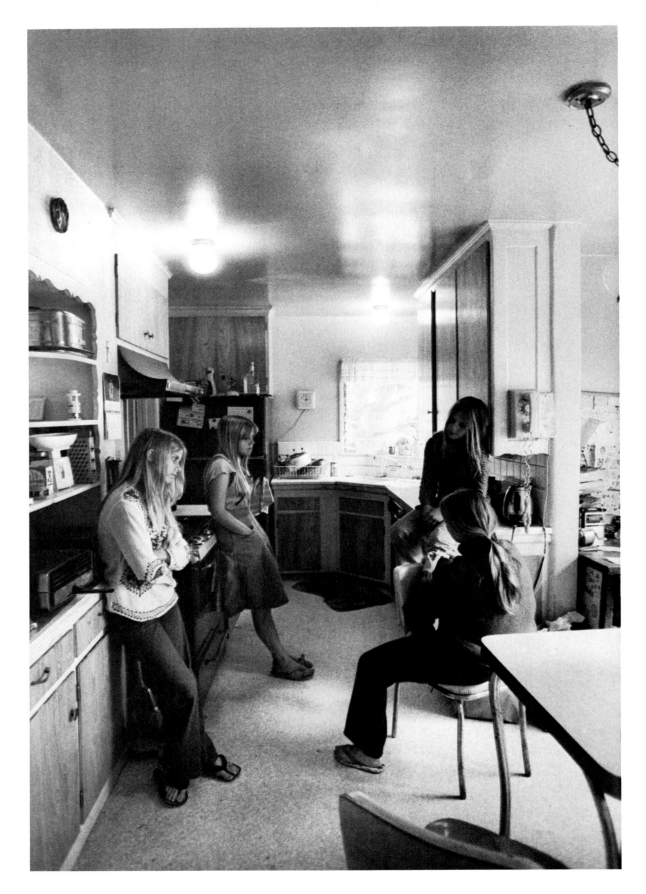

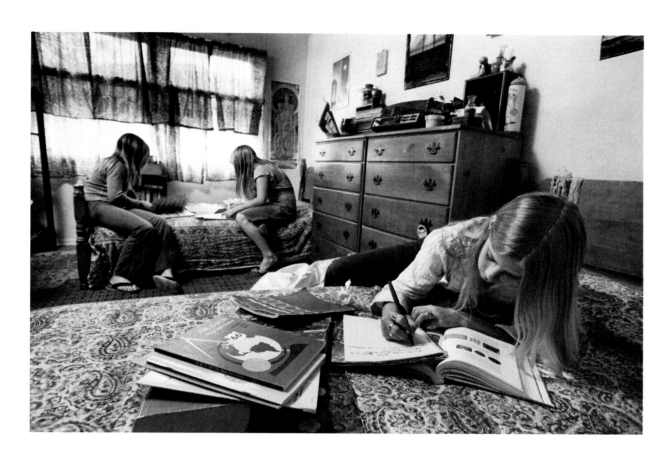

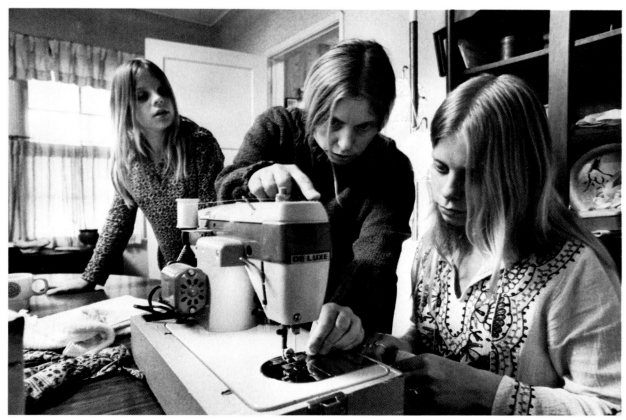

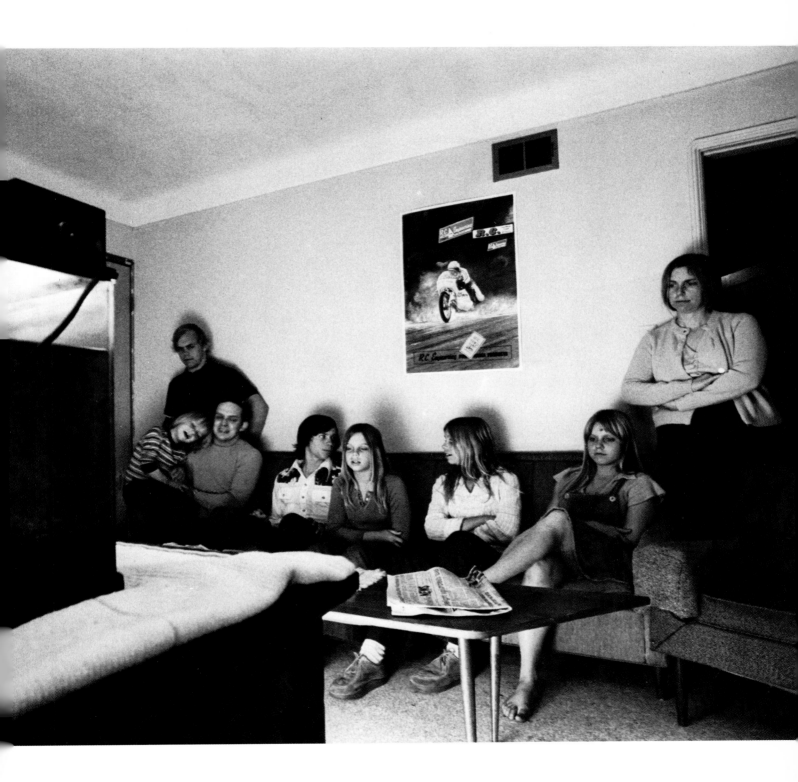

John D. Dorian (Grandfather)

Poway, California

A man who speaks eight languages, who sailed the seven seas, and who knows every major port around the globe like the back of his hand, is not a man who will sit still even at age 76. John presently lives with his daughter Jeanette Betancourt where the view is not swelling crests of waves but beautiful, tall mountain peaks outside of San Diego.

Ebullient, courtly, with a charisma that attracts people of all ages, John is retired, but active. He enjoys the company of his grandson Charles, 16, who is one of ten grandchildren and three great-grandchildren. Rain or shine, a late afternoon five-mile walk with the family dog Gaylord, a springer-spaniel, is a daily ritual for this energetic elder American. Friendship and respect—be it with the local mailman or an official at his neighborhood bank, or others in his circle of acquaintances—are the chief ingredients of his relationships.

Holder of Chief Mate's papers, of which he is singularly proud, John worked in the New York harbor for many years on ferries and tugs. He believes he was the youngest Third Mate ever to sail out of New York with the Merchant Marine. John has studied every government around the world and states: "Our Constitution is the best in the world, bar none."

Arnold Newman photographed scenes of the world and days of John Dorian for others to share. John is good company, but knows when to modulate his hearty, booming voice so that even the ducks on Poway Lake come close and the backyard petunias seem soothed by its gentleness.

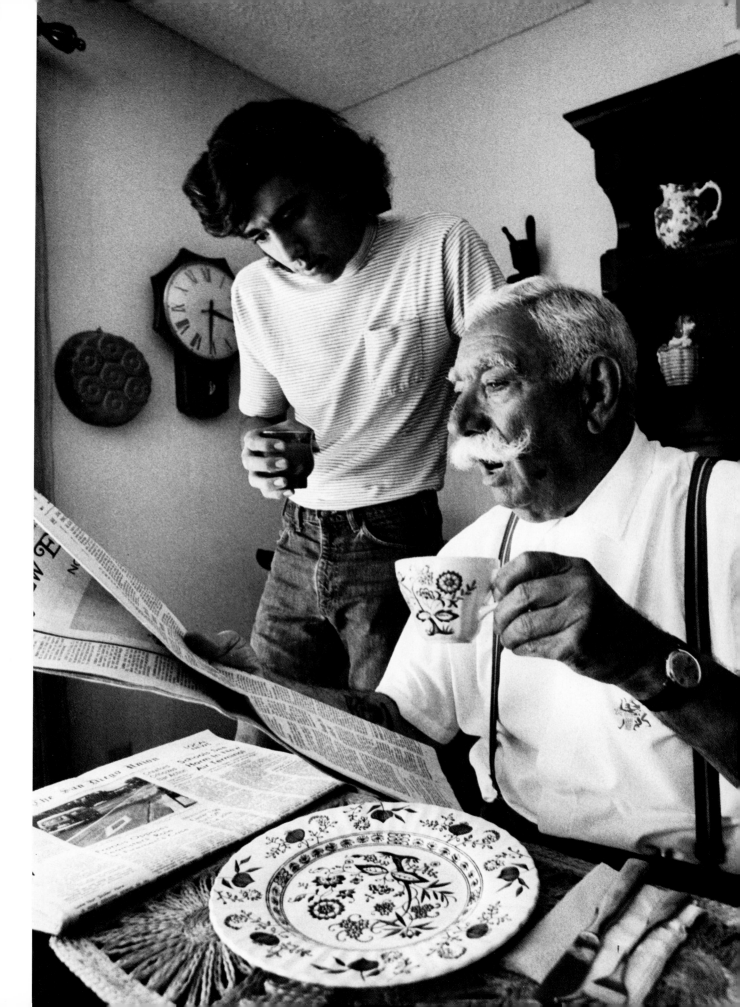

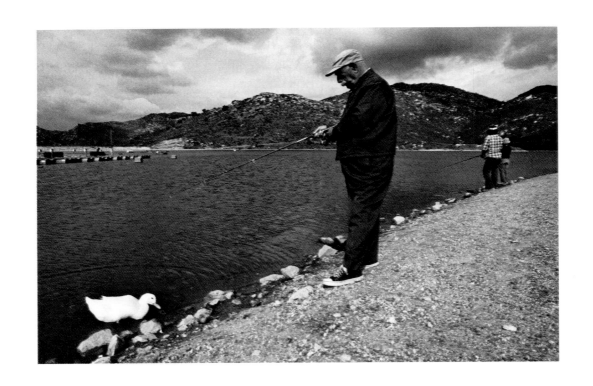

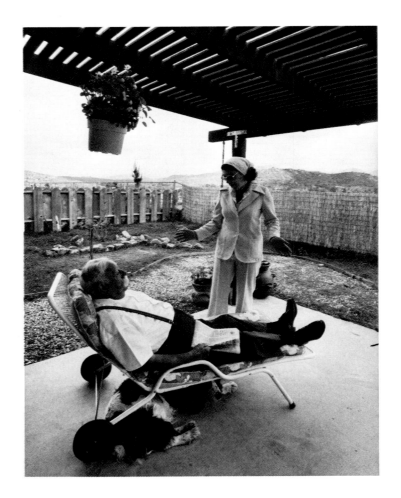

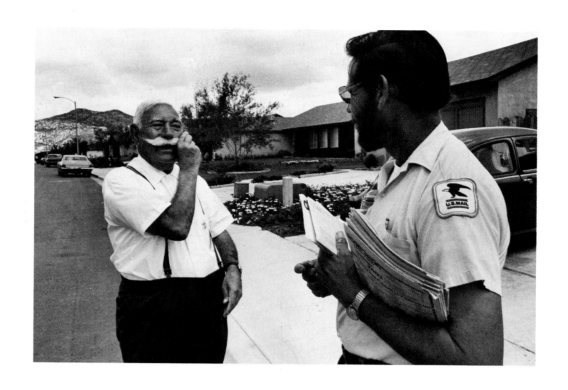

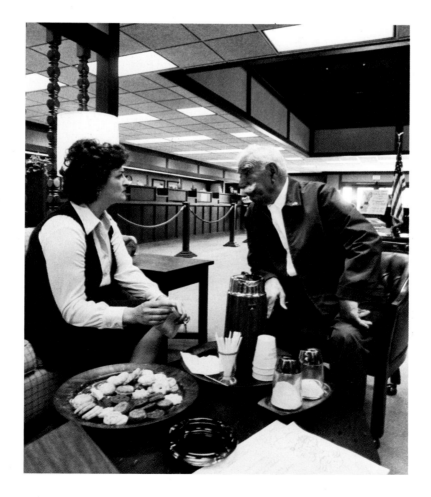

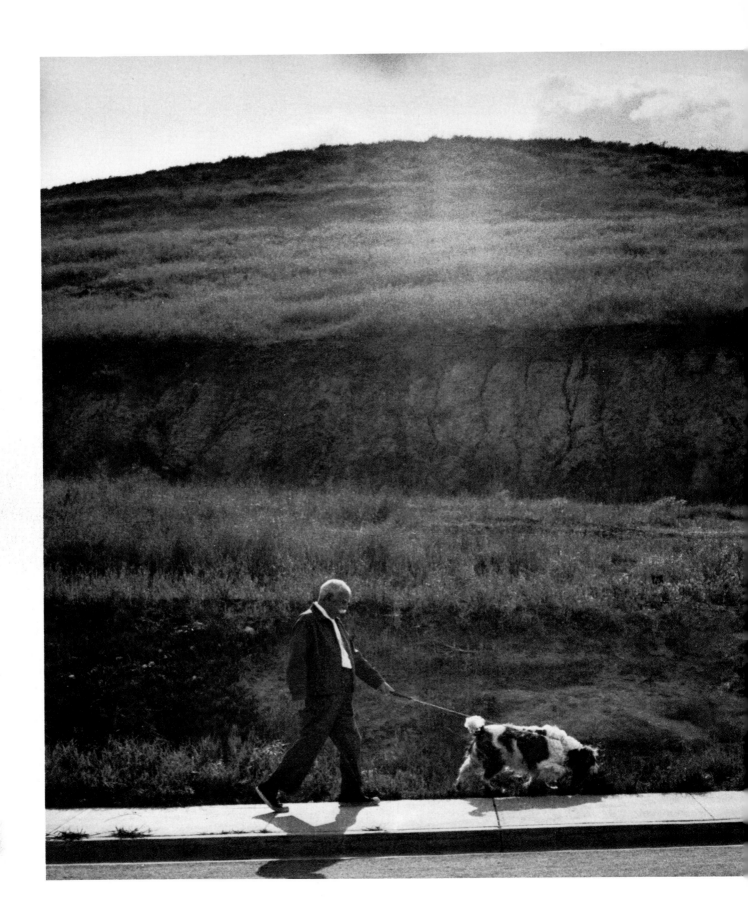

The National and Regional Families

You will not find photographs by Arnold Newman on the following pages. Illustrated here are the very best of the over 5000 snapshots that poured in from all parts of the country for FACES. The photos were taken by close friends and loving relatives in attempts to capture typical American faces. The judges looked for photographs that best captured the qualities of character, personality, emotion, strength, warmth, and humanity. They found many, but after long hours of debate, they narrowed their selection to 48 regional winners.

For each of four regions of the country—the Northeast, Southeast, Northwest, and Southwest—twelve winners were selected in the following categories: Grandmother, Grandfather, Mother, Father, Young Adult (male), Young Adult (female), Teenage Boy, Teenage Girl, Pre-teen Boy, Pre-teen Girl, Baby Boy, and Baby Girl. Thus, each section of the country emerged with its own regional twelve-member "family." After another long selection process, national winners were then chosen by the judges from among the "regional families."

On pages 100 to 105 are the twelve photographs that determined the national winners. The photographers who took these snapshots deserve special recognition for portraying their subjects so beautifully and for capturing the qualities of character, personality, emotion, strength, warmth, and humanity.

On pages 106 to 111 are the 36 photographs that determined the regional winners. Again the photographers deserve special credit for capturing the qualities the committee was seeking. In spirit, and in the basic criteria sought by the committee, these 36 regional winners are an integral part of FACES.

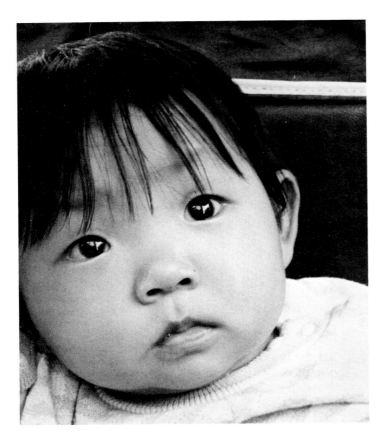

Photographer: Michael A. Schillaci
Subject: Tracey Joy Schneider
City and State: Centereach, New York
Category: Baby Girl

Photographer: Marie T. Marchese
Subject: Matthew Marchese
City and State: Grosse Point Woods, Michigan
Category: Baby Boy

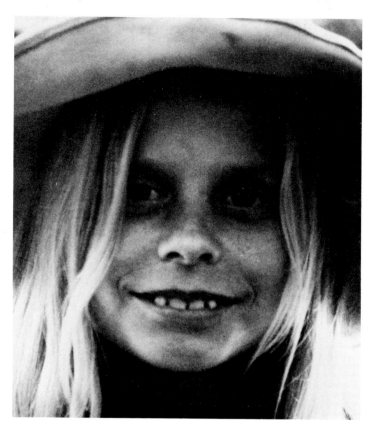

Photographer: Claudia Walion
Subject: Sue Brady
City and State: Westchester, California
Category: Pre-Teen Girl

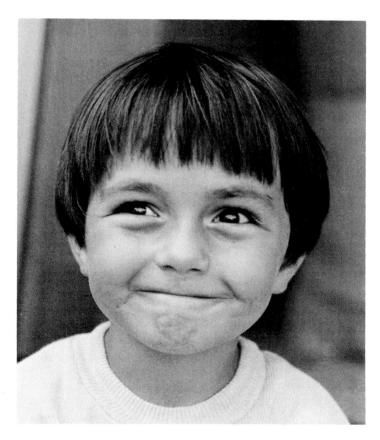

Photographer: Janice Hildebrand
Subject: Jason Jardine
City and State: Gaithersburg, Maryland
Category: Pre-Teen Boy

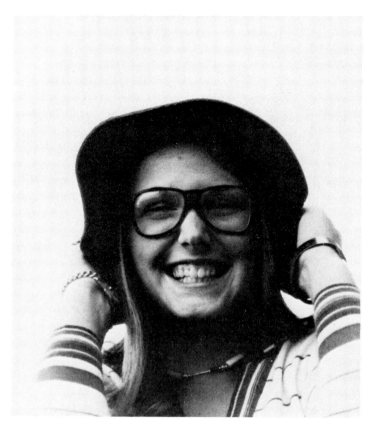

Photographer: Michael F. McMillin
Subject: Amie Willis
City and State: Grandview, Missouri
Category: Teenage Girl

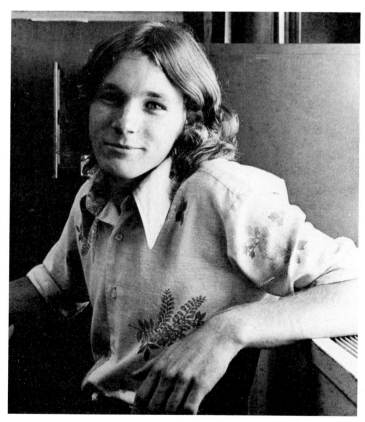

Photographer: Patricia H. Yznaga
Subject: Paul Wagner
City and State: San Antonio, Texas
Category: Teenage Boy

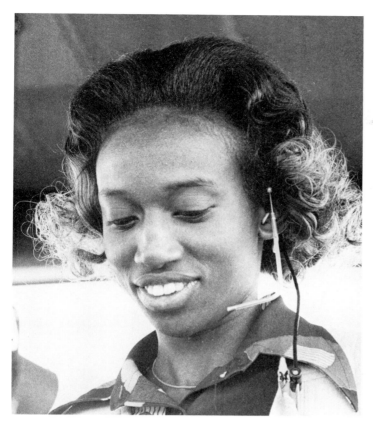

Photographer: Dr. George W. Loesch
Subject: Ruthie Scott
City and State: Mansfield, Ohio
Category: Young Adult (Female)

Photographer: Mary Slyby
Subject: Mark Gridley
City and State: Columbus, Ohio
Category: Young Adult (Male)

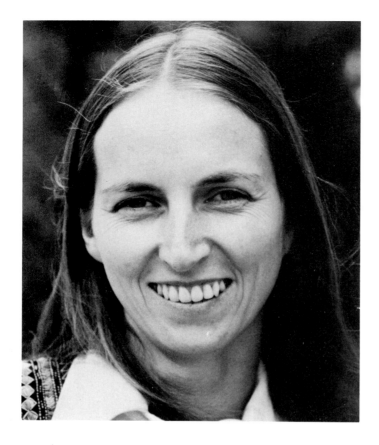

Photographer: Carroll Blue
Subject: Nancy Cowan
City and State: San Diego, California
Category: Mother

(A national winner, Nancy Cowan decided for personal reasons not to be included in the front part of this book.)

Photographer: Leo S. Halpern, D.D.S.
Subject: Milton Blackstone
City and State: Short Hills, New Jersey
Category: Father

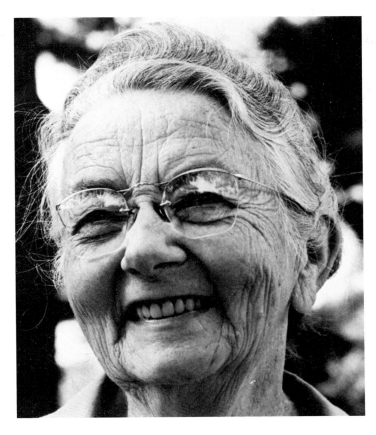

Photographer: Keith Briggs
Subject: Keziah Patterson
City and State: Marshalltown, Iowa
Category: Grandmother

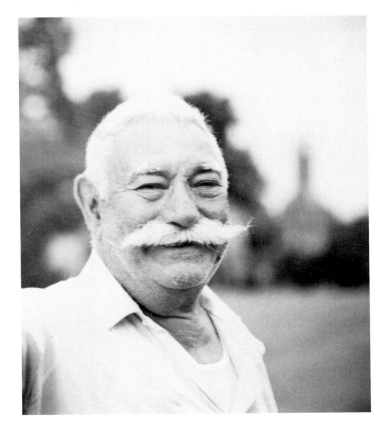

Photographer: Charles A. Giardino
Subject: John D. Dorian
City and State: Poway, California
Category: Grandfather

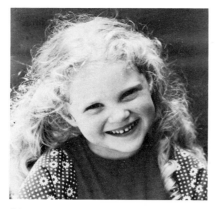

Photographer: Marge Lapham
Subject: Dusty Webb
City and State: Houston, Texas
Category: Baby Girl

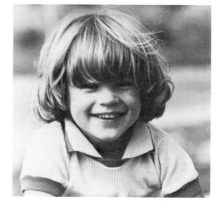

Photographer: Marge Lapham
Subject: Reggie Lapham
City and State: Houston, Texas
Category: Baby Boy

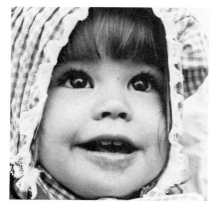

Photographer: Keith Briggs
Subject: Alica Hutzel
City and State: Le Grand, Iowa
Category: Baby Girl

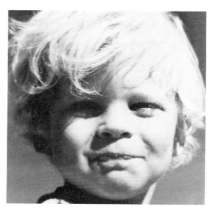

Photographer: Janice Sanborn
Subject: Christopher Sanborn
City and State: Roswell, Georgia
Category: Baby Boy

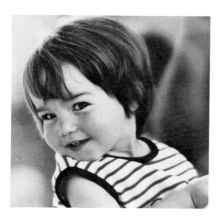

Photographer: John Markanton
Subject: Kirsty Bowen
City and State: Valencia, California
Category: Baby Girl

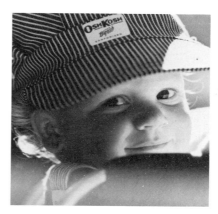

Photographer: Linda Reinink-Smith
Subject: Oliver Macrae Smith
City and State: Bellingham, Washington
Category: Baby Boy

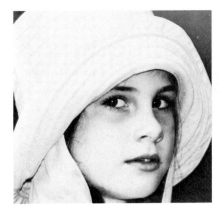

Photographer: Elaine Fetting
Subject: Rachel Hulen
City and State: Scarsdale, New York
Category: Pre-Teen Girl

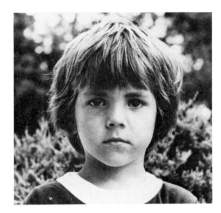

Photographer: Wayne Panyan
Subject: Craig Peters
City and State: Livonia, Michigan
Category: Pre-Teen Boy

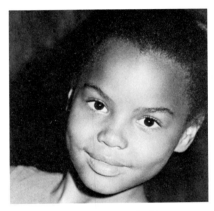

Photographer: Paul Hoffman
Subject: Wanda Carr
City and State: St. Louis, Missouri
Category: Pre-Teen Girl

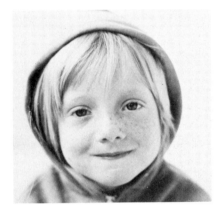

Photographer: Dana Sue Cowen
Subject: Ace Bongwater Johnson
City and State: Cuddebackville, New York
Category: Pre-Teen Boy

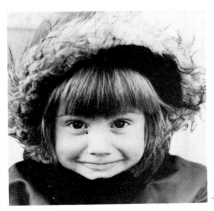

Photographer: Kerry Bowen
Subject: Lisa Marie Dunn
City and State: West Des Moines, Iowa
Category: Pre-Teen Girl

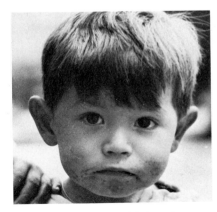

Photographer: Jim McLeod
Subject: Servando Mendez
City and State: New Orleans, Louisiana
Category: Pre-Teen Boy

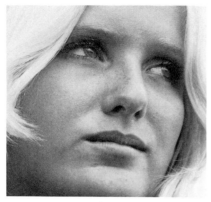

Photographer: Brian Stoney Hill
Subject: Barbara Helen Joyce
City and State: Orlando, Florida
Category: Teenage Girl

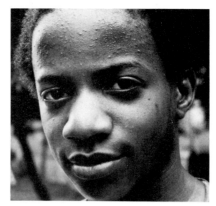

Photographer: Irving Georges
Subject: Craig Georges
City and State: Plainfield, New Jersey
Category: Teenage Boy

Photographer: Betsy Leacock
Subject: Ellen Leacock
City and State: Ypsilanti, Michigan
Category: Teenage Girl

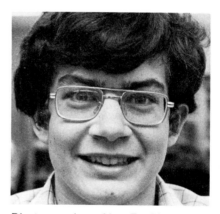

Photographer: Alan Perkins
Subject: Self-Portrait
City and State: Richwood, Ohio
Category: Teenage Boy

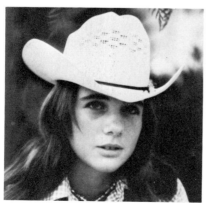

Photographer: Wesley K. Bilodeau
Subject: Marty Robbins
City and State: Tucson, Arizona
Category: Teenage Girl

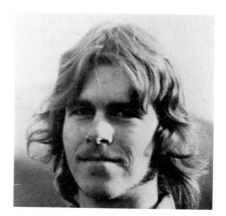

Photographer: Linda L. L. Johnson
Subject: Clark Zimmerman
City and State: Walnut Creek, California
Category: Teenage Boy

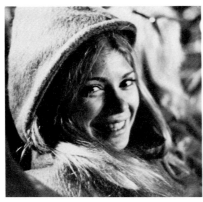

Photographer: Christie A. Plank
Subject: Self-Portrait
City and State: Pasadena, California
Category: Young Adult (Female)

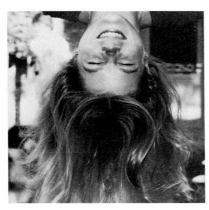

Photographer: Jay Fraley
Subject: Ellie Caldwell
City and State: Abilene, Texas
Category: Young Adult (Female)

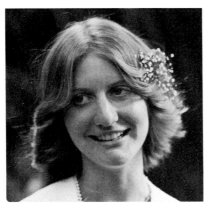

Photographer: Philip C. Moulthrop
Subject: Joyce Moulthrop
City and State: Brighton, Massachusetts
Category: Young Adult (Female)

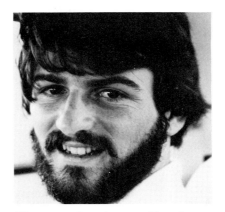

Photographer: Loretta Poggi
Subject: Ron Ferrara
City and State: New Providence, New Jersey
Category: Young Adult (Male)

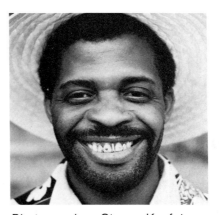

Photographer: Steven Kayfetz
Subject: John Hunter
City and State: Pittsburg, California
Category: Young Adult (Male)

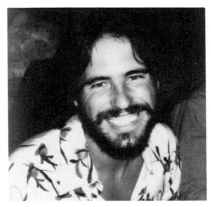

Photographer: Karen Wimbish
Subject: Bubba Chambers
City and State: Pasadena, Texas
Category: Young Adult (Male)

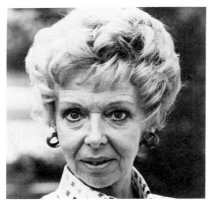

Photographer: Richard Hanousek
Subject: Ann Hanousek
City and State: Maple Heights, Ohio
Category: Mother

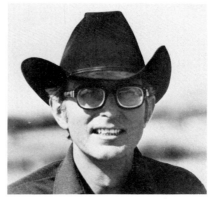

Photographer: Sue Meacham
Subject: Frederick C. Meacham
City and State: Sedalia, Colorado
Category: Father

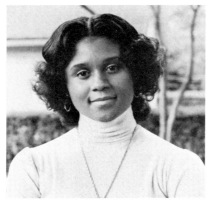

Photographer: George De Freese
Subject: Anne De Freese
City and State: Rahway, New Jersey
Category: Mother

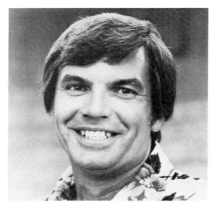

Photographer: Marge Lapham
Subject: Tommy Gordon
City and State: Fort Worth, Texas
Category: Father

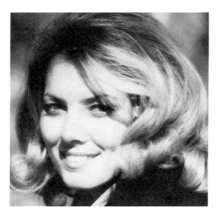

Photographer: William M. Burns
Subject: Beverly Burns
City and State: Tampa, Florida
Category: Mother

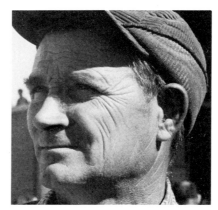

Photographer: Harry G. Dotson
Subject: Walter A. Soplata
City and State: Newbury, Ohio
Category: Father

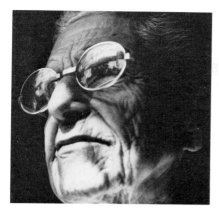

Photographer: Linda Regolizio
Subject: Eva Coleman
City and State: New Hyde Park, New York
Category: Grandmother

Photographer: James M. Johnston
Subject: Self-Portrait
City and State: Tucson, Arizona
Category: Grandfather

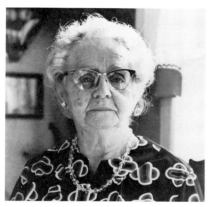

Photographer: Bruce Henderson
Subject: Maude Ebberts
City and State: Eureka, Kansas
Category: Grandmother

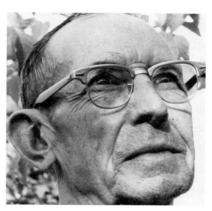

Photographer: Joye Durham
Subject: W. J. Laws
City and State: Harlan, Kentucky
Category: Grandfather

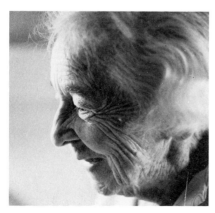

Photographer: Lorenzo Baca
Subject: Louise Arnold Fry
City and State: Columbia, California
Category: Grandmother

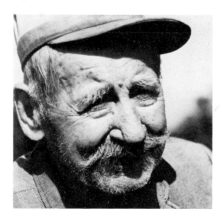

Photographer: Rozelle Gill
Subject: Ignatz Solar
City and State: Greenwood, Wisconsin
Category: Grandfather